IMPASTO

Detail of *Grapes, Bottles, and Coconut* (page 132)

DAVID LYLE MILLARD

IMPASTO

WATSON-GUPTILL PUBLICATIONS / NEW YORK

I would like to dedicate this book to my children,
Nadine Berman, Peter Millard, and Wendy Stanton

Editorial concept by Bonnie Silverstein
Edited by Sue Heinemann
Designed by Bob Fillie
Graphic production by Ellen Greene
Text set in 12-point Palatino

First published in 1987 in New York by Watson-Guptill Publications,
a division of Billboard Publications, Inc.
1515 Broadway, New York, N.Y. 10036

Library of Congress Cataloging-in-Publication Data

Millard, David Lyle.
 Impasto.

 Includes index.
 1. Painting—Technique. I. Title.
ND1500.M52 1987 751.45 87-23028
ISBN 0-8230-2542-X

Distributed in the United Kingdom by Phaidon Press Ltd., Littlegate
House, Ebbe's St., Oxford

Manufactured in the United States of America

First printing, 1987

1 2 3 4 5 6 7 8 9 10/92 91 90 89 88 87

Acknowledgments

Detail of *The Straw Hat* (page 44)

I would like to thank:

My wife, Edith Carol Millard, who has nurtured a creative painting climate with enthusiasm and encouragement for these past thirty-four years.

My mother, who started me at the Montclair Art Museum in sixth grade.

Alfred Krakusin, my painting professor at Colgate University, who initially got me into color in oils and shared my in-depth interest in impasto handling.

Bernard Lamotte, my painting instructor at the Art Students League, for taking me into his studio to observe his brilliant manipulation of color and pigment with his round brushes.

My professional artist friends—Jack Callahan, Emile Gruppé, Tom Nicholas, Paul Rahilly, and Paul Strisik—for sharing their ideas and giving encouragement.

My senior editor, Bonnie Silverstein, who kindled the fire to commence this work on impasto and guided my writing efforts.

My manuscript editor, Sue Heinemann, who carefully shaped the text into its final form.

My designer, Bob Fillie, for his skillful visual presentation of this rather complicated material.

Detail of *Silver Pitcher* (page 46)

CONTENTS

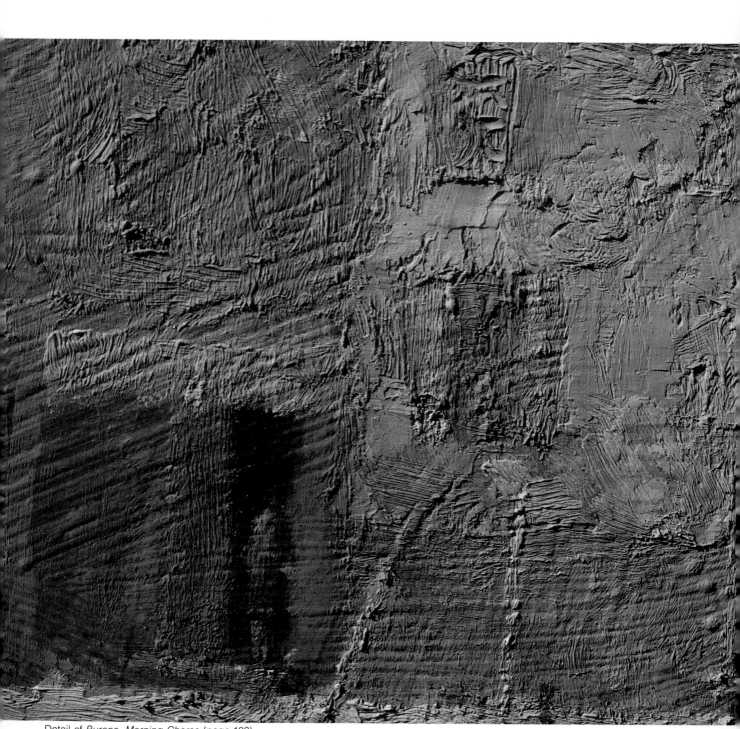

Detail of *Burano, Morning Chores* (page 102)

INTRODUCTION

Impasto has to do with the thickness of oil pigment. I like to think of every layer of paint—beyond the initial turps wash—as a layer of impasto, even though this is not the traditional definition. The excitement of using impasto, and varying the thickness of the paint, is that you can give each new painting a different personality. If you're in a rut, producing oils with the same lackluster texture, applied in the same manner, year after year, learning about impasto should instill new life into your paintings.

The idea of this book is to open up to you the many different possibilities of impasto. As you paint, you should be continually setting yourself new problems and challenges. You might, for example, ask: "How can I enliven the texture and finish of my painting? What happens when I contrast thin paint with thicker impasto? Can impasto add to the three-dimensional illusion in a painting? What about creating atmospheric effects with impasto, or catching the light and establishing a sparkling accent?" The examples in this book should help you answer these and other questions, while encouraging you to explore other uses of impasto on your own. Experiment as much as possible—trying out different grounds, different oil mediums, different palette knife or brush techniques. Just altering your whites can be a key to new effects. The more you explore, the more you'll learn and grow as a painter.

An important part of the learning process is looking at how other artists have used impasto. Among the outstanding paintings by Monet, for example, are his haystack and cathedral series. In these he built up the impasto by overpainting layers of color, in irregular thicknesses, creating a vibration on the surface. Rembrandt and Bonnard used thick impasto somewhat differently—to accent a particular feature. With Rembrandt, it might be a cheek or a metal helmet; with Bonnard, a few pieces of fruit in a bowl. It was by observing how these and other artists applied impasto in particular works that I became aware of its special excitement and the way it can contribute to a painting's individual character (see the list of artists on page 142).

To spark your interest in impasto, I've included sixty impasto variations in this book, with many close-up details—so close up that at times you can almost feel the paint. My intention is to stimulate your own creative approach, to encourage you to individualize your actual handling of the pigment with each new subject. Playing with thick and thin variations can be fun, and it can make your painting more dynamic.

1.

MATERIALS AND TECHNIQUES

I love to experiment. In fact, I've been experimenting all my painting life. As far as I'm concerned, nothing is final. Everything is open to change. I'm continually testing new colors, different brands of the same color, and trying to figure out different ways to get the paint down. I look at an old (or modern) master painting that attracts me, and immediately try to figure out how it was done. I'd like to share some of my experiments (as well as my research) with you in this section. Study the ideas carefully—you'll find them illustrated later in specific paintings in the book. This is really a reference section, one you'll be turning back to as you read. It's also the most basic chapter in the book, since it details the way I work. Read it, understand what I'm doing and why, and take from it what you can use. Remember, you don't have to try it all. But experiment with some of the methods I suggest and try some new ideas of your own. If you don't experiment, you don't grow!

STUDIO EQUIPMENT AND SETUP

I maintain two studios, one in each of my residences—St. Thomas and Massachusetts. The St. Thomas studio, illustrated here, has a 6-foot (2 m) long table on casters that provides an excellent catchall for paints, brushes, mixing and cleaning materials—and also makes a great moveable table for a still life setup.

I use a portable French easel. The photo shows it just before I'm ready to paint. Note the textured panel on the easel, and my palette with the paints neatly arranged around the edges. (I'll discuss this shortly.) Also, note the sketchbook that lies open on the palette for reference. I work almost as much with my initial quick sketch as I do with the actual setup because it shows me how I plan to approach the painting in terms of emphasis, contrasts, point of view, and so forth, solving many of my technical problems before I even start to paint.

The studio lighting comes from the north, but if I wish, I can move the setup to my western porch to use a warmer light.

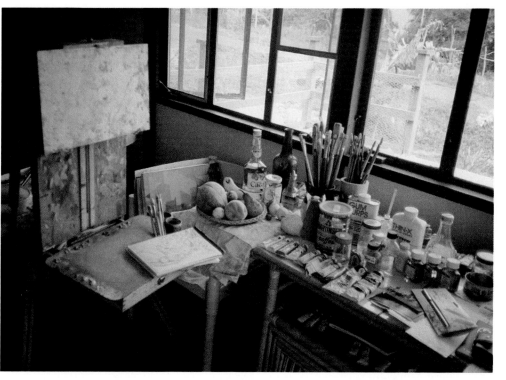

My studio in St. Thomas, set up for a painting session.

The palette shown here is Masonite. After many years of use, a cool gray patina has formed on its surface that effectively sets off the brilliant tropical colors of St. Thomas. In New England, I switch to a birchwood palette (shown in the photos on whipping whites, page 18)

because the warm wood surface is better suited to contrast with the gray skies and deciduous trees of the stark New England spring and fall. As I work, I continually wipe off the central mixing area to prevent my colors from getting muddy and to give me a clean mixing area.

COLORS

I own many paints—and many brands of the same color. All are different. I select my palette of colors in advance before I start each painting and never put every color I own in the same painting. For example, I have about six different

brands of cadmium red and yellow and, depending on the hue, I choose brands accordingly. Despite the number of colors I own, I occasionally limit my palette to as few as three colors, or maybe eight or nine colors, depending on my mood and the subject. (It's also a good discipline.)

I squeeze out generous amounts (from ½-inch to ¾-inch ribbons of paint) on the palette. At the end of a painting day, instead of throwing out the excess color, I mix it with white and add it to panels or canvases awaiting additional layers of painting grounds (see the section on toning grounds).

My palette is laid out starting with the yellows in the lower left, moving upward to cobalt violet, then across through greens and blues to the earths. Specific mixtures will be discussed with individual paintings. The palette is as follows:

Cadmium yellow light
 or cadmium yellow pale
 (*I use one or the other; never
 both in the same painting*)

Yellow ochre
 (*Winsor & Newton or Utrecht;
 both are different*)

Cadmium yellow medium
 or cadmium yellow deep
 or cadmium yellow orange

Cadmium orange
 (*or sometimes I'll mix a red
 and yellow to get orange
 if I don't happen to have
 it out on the palette*)

Quinacridone red
 (*such as Liquitex acra red
 or Winsor & Newton
 permanent rose*)
 and/or rose madder deep
 (*Grumbacher or Bellini*)

Manganese violet
 (*or other violets such as
 LeFranc & Bourgeois
 mineral violet*)

Cobalt violet
 (*there are many variations;
 LeFranc & Bourgeois's
 cobalt violet is different
 from Winsor & Newton's*)

Permanent green light
 (*I use two or three greens
 at a time, or mix it with
 yellow and blue, depending
 on what's out on my palette*)

Sevres green
 (*Rembrandt brand,
 a light phthalo green*)

Cobalt green
 (*Winsor & Newton*)

Viridian or
 phthalo green (*I rarely use
 phthalo because it's a bit dark;
 I use Sevres green instead
 when I want a phthalo green*)

Turquoise blue
 (*Liquitex brand—they have
 many blues and purples, good
 for getting a wide range
 of colors without mixing*)

Cerulean blue

Cobalt blue
 (*Utrecht cobalt deep;
 Blockx has a beautiful but
 expensive cobalt blue*)

Ultramarine blue
 or phthalo blue
 (*either ultramarine or
 phthalo, not both*)
 or permanent blue
 (*Winsor & Newton,
 used instead of cobalt
 or ultramarine*)

Raw umber

Venetian red
 (*both Bellini and Liquitex
 make a lovely Venetian red;
 color varies with the brand*)

Rouge de pouzolles
 (*LeFranc & Bourgeois*)
 or terra rosa (*Grumbacher*)

Burnt sienna
 (*color varies widely
 with manufacturer;
 Winsor & Newton and
 Blockx make a beautiful
 burnt sienna*)

Burnt umber
 (*seldom used unless
 I'm mixing grays*)
 or ivory black
 (*one or the other, never both*)

Whites
 (*titanium/zinc combinations,
 Permalba, Shiva mixed with
 flake, Winsor & Newton
 foundation white, zinc.
 These are my painting whites—
 I pile one or two of them
 in the center of the palette
 for easy accessibility
 when mixing with colors.*)

Buying Paint. In deciding whether to buy a particular tube of paint, I use the Lamotte technique, named after one of my art teachers. Unscrew the cap and touch a little bit of paint onto your left thumbnail (if you're right-handed). Then rub the paint across your nail with

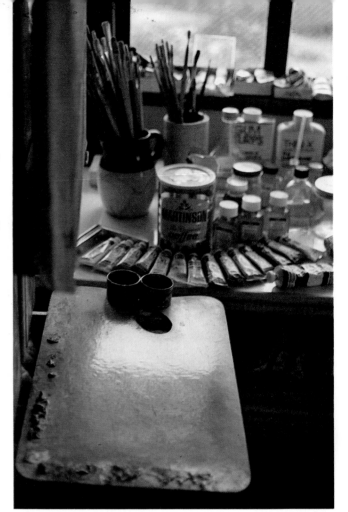

Closeup of my palette setup.

the other thumb to check the luminosity of the color. If it's too opaque, don't buy it—same holds if it's too oily or weak-looking. (Of course, if you *want* an opaque color, then this might be just what you're looking for.)

BRUSHES

Can an artist ever have enough brushes? Mine have been acquired over the years and sit in my studio, awaiting their turn to be used, in coffee cans or earthenware bowls. The longer I paint, the more I am convinced that brushes get better as they get older—until some are really too worn down to be of any use. Many brushes have become pets of mine.

I like the feel of having a few brushes in my other hand as I paint, and I keep at least four "going" at the same time: one for warm light colors, one for warm dark colors, one for cool light colors, and one for cool

darks. (I use the cool light brush for pure white paint.)

Suggested Brushes. The size brush I use depends on the size of the painting—the larger the painting, the larger the brush. I keep a variety of sizes around. My favorites are bristle brushes, generally Grumbacher's Mussini flats and rounds—perhaps because my teacher initially recommended them.

Flat bristle brushes are my workhorses. They carry more paint than brights because the bristles are longer, which means I can scumble longer strokes without running out of pigment. They give me a broken brushstroke that doesn't cover the top layer completely so the ground colors show through, giving an atmospheric quality to the painting. In flats I like Grumbacher's Gainsborough series and their series 3011 red sables. I also use Simmons's Signet series 40.

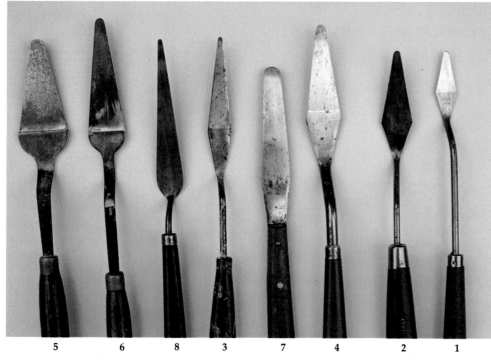

My favorite palette knives (numbered according to the chart below).

Brand	Blade Length	Width	Point Width	Characteristics
1. Ecolse no. 112	1 5/16"	7/16"	3/32"	stiff
2. Langnickel 033	2 1/16"	7/8"	1/8"	semi-stiff
3. Gemex	2 5/8"	1/2"	1/16"	rubbery
4. Winsor & Newton	2 3/4"	3/4"	3/16"	springy (also used in whipping whites)
5. Unknown	2 1/2"	1 1/16"	5/16"	semi-reinforced heel
6. Unknown	2 3/8"	3/4"	3/16"	reinforced heel
7. Unknown (a "cheapy")	4"	9/16"	5/16"	good steel, slight curve
8. Unknown	3 1/2"	1/2"	1/8"	draws into impasto well, very sensitive

I use round bristle brushes to scrub, scumble, and roll on the paint, working forward and backward usually onto dry color areas or working into fresh impasto across the grain of a textured ground. I like several brands of rounds: Grumbacher's Mussini series, Delta's El Greco series, ArtSign's Imperial series, and Winsor & Newton's Series A. Old rounds—the scruffier the better—are great for texturing the paint.

Bristles with exceptionally long hairs are called Whartons. They're great for tentative, poetic strokes and interesting atmospheric effects. I use ArtSign's series 720 in no. 8 and larger sizes. They're indispensable for the freedom of motion they provide. Judging from old photos, I think Monet used long-haired bristle brushes like these in his large water lily paintings. I use the smaller sizes for sketching my initial drawing onto the support and longer ones for scumbling over pre-painted areas.

Buying Bristle Brushes. I call this the Krakusin technique after my painting teacher at Colgate University who first suggested it. It works for bristle brushes only (you can always file sables down if they're badly shaped). Make a fist with your non-painting hand, squeezing your thumb over the forefinger to produce a bulbous muscle shape at the thumb joint. Now pull the brush bristles across this muscle as though you were stroking paint onto the canvas. If the brush feels scratchy or you can detect a few "rude" bristles or lumps along the hair, don't buy it.

Cleaning Brushes. My brush cleaner is an old coffee can with an upside-down empty old tunafish can, pierced with holes, sitting inside it. I fill the coffee can with paint thinner to nearly an inch above the tunafish can. When I'm painting and my brushes get too many colors on them, I swish them around in the paint thinner and wipe them dry on an

old paint rag. (Incidentally, never let a brush soak upside down in the paint thinner or it will destroy the bristles.) At the end of a painting session, I clean the brushes again in pure gum spirits of turpentine. I used to scrub them in soap and water and run them against the palm of my hand, but I stopped after reading *Artist Beware* by Michael McCann (Watson-Guptill, 1979). Why scrub poisonous cadmiums, lead (flake) whites, and other harmful chemicals into your palm pores for an early wake?

PALETTE KNIVES

I used to think palette knives were gadgets useful only for trick effects, but the longer I paint the more I realize that they can really carry their own weight when they're understood and become an extension of the artist's hand. My collection of knives was acquired over a period of forty years of painting and I'll list only a few of my favorites for you here—I have many, many more—just to show you the variety of knives available. Try many kinds of knives until you get to know the ones you feel comfortable with and enjoy using. Remember, you're the one driving the bus. Only you can know what you want. *Note*: The knives here are listed according to size, and the numbering in the illustration refers to the numbering in this chart.

Painting with a Knife. To show you how to handle the palette knife, I've reconstructed some of the knifework in two of my paintings, *African Store* (see also page 140) and *Pumpkin Seeds* (see also page 33).

In painting *African Store*, after I finished the last brushstrokes, I let the painting rest for an hour, then drew my Winsor & Newton 2¾-inch palette knife (no. 4) across the semi-stiff impasto, altering the brushmarks on the stairwell to resemble a plasterer's trowel-like finish, giving the area a more believable architectural quality.

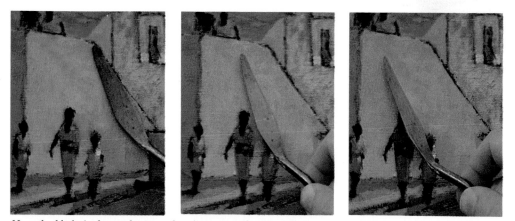

Here the blade is dragged across the pigment at the same angle as the stair rail.

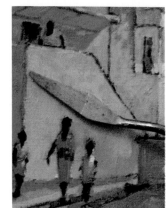

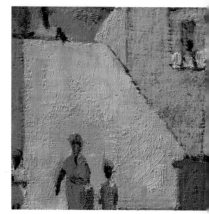

Now the knife if pulled downward at an angle parallel to the stairwell.

This detail shows the results of all this knifework (see also page 140).

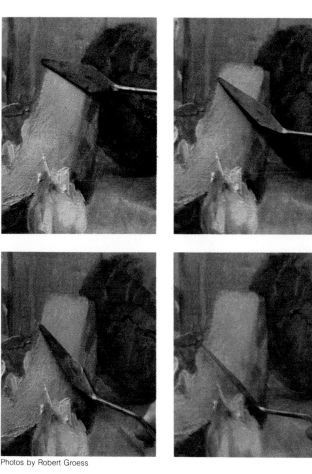

Photos by Robert Groess

In Pumpkin Seeds, *the knife is pulled downward, twisted clockwise, and lifted in one simple, quick movement that both removes and flattens the pigment (see also page 33).*

In *Pumpkin Seeds*, after critically examining the painting when I finished it, I decided that both ends of the pumpkin were textured too similarly with heavy impasto and there was a battle between the sides for attention. After the paint set an hour, I drew my Langnickel 2¹⁄₁₆-inch palette knife blade (no. 2) across the impasto on the right to quiet the brush-strokes there.

MEDIUMS AND FORMULAS

There are many excellent prepared mediums on the market. I particularly recommend Liquitex Rapid-Set oil medium and Winsor & Newton Liquin; both speed drying time. Also, get *Formulas for Painters* by Robert Massey, published by Watson-Guptill. It contains 200 formulas for mediums, grounds, gesso, and other items for artists. A must to read or own!

Much of my work is dry-looking because I soak out much of the linseed oil in my whites—and even in the more buttery oil colors—on brown paper bags (see "whites" section) for a matte impasto look. So I use very little medium, though I add a few drops of linseed or stand oil to my turps to maintain the elasticity of the paint film.

I use two different turpentine mixtures and five different oil mediums for various purposes. I begin with pure gum spirits of turpentine (never steam-distilled), purchased fresh each spring from my local paint supply store. The formulas for these mixtures follow.

Turpentine Mixture No. 1. I use this for paintings with a dry matte finish both in the grounds and in the later heavier impasto accents. The medium is a ten to one ratio of turpentine to linseed oil, poured and stirred into a clean one-pint bottle.

Turpentine Mixture No. 2. This is used when I plan to finish up with thicker (and oilier) impasto paints such as those in *Gooseberry*

Chutney Jar (page 115). It consists of a ten to one ratio of turps to stand oil, also poured into a clean glass bottle labeled carefully.

Oil Medium No. 1. This is used as a medium in paintings containing turpentine mixture no. 1 and is a five to one ratio of turpentine to linseed oil. It's actually an extension of the turpentine mixture: as I continue beyond the first stage of painting, I'll add a drop of linseed oil to the turpentine mixture.

Oil Medium No. 2. This is the same as oil medium no. 1, but with stand oil instead of linseed oil. Like the previous medium, a drop of stand oil is added to the second turpentine mixture as the painting progresses.

Oil Medium No. 3. This is a 50–50 blend of turpentine and stand oil, stirred well and stored in a three-ounce brown screw-capped prescription bottle.

Oil Medium No. 4. This and oil medium no. 5 are a bit more complicated because I first make up an undiluted version, then add turpentine to dilute the mixture. In a clean, screw-capped glass bottle I place 2 ounces of turpentine and stir 2 ounces of damar varnish into it. When it's dissolved (turpentine *substitutes*, incidentally, won't dissolve damar varnish), I add 2 ounces of linseed oil to it and mix well. This is the undiluted version. I now take one part of this mixture and combine it with four parts pure turpentine for a diluted version; I then mark the bottles accordingly.

Oil Medium No. 5. This is essentially the same as the preceding mixture, with stand oil substituted for linseed oil. Again, both versions are marked "diluted" and "undiluted" accordingly. I use oil mediums no. 4 and 5 in small amounts (either one or the other, not both together) in paintings that are done *alla prima* in a single sitting or in the later stages of the painting process, applying the principle of "fat over lean." Sometimes I let my paintings "ripen" for a while, either because I'm busy painting others or

because I'm not quite sure what I want to do on them next. If I've let more than a month pass, I return to a medium with less oil in it than the one previously used when the painting was wet and begin the "fat over lean" process again.

To Speed Drying. If I'm going on a painting trip or need to speed the drying time for one reason or another, I'll add 2 drops of cobalt siccative to 3 ounces of oil medium no. 3, 4, or 5 and carry the medium in my paint box in a screw-cap prescription bottle.

PALETTE CUPS

I keep my mediums in double palette cups clipped to the right side of my palette. The oil mixtures (linseed or stand oil—I use one or the other in a painting, not both) are in the upper cup and mixtures containing pure gum spirits of turpentine are in the lower cup. The size of my palette cups varies with the size of the painting I'm working on. (Since a large painting requires more medium, I'll use larger cups.)

I dole the various mixtures out of well-labeled bottles using an old trick: I syphon medium from the bottles with a plastic soda straw, placing my finger over it to hold in the mixture, then releasing the medium into the palette cup by removing my finger. At the end of the day, if I plan to continue painting the next day and there's enough medium to save, I cap the cup with a weighted styrofoam lid. If I want to dispose of the residue, I don't toss it down the sink but instead pour it into an old medicine bottle for eventual dumping (when I've filled the bottle) in the town's toxic waste disposal area. (Never dispose of chemicals carelessly!)

As my painting progresses, I gradually increase the amount of fat in my painting medium, working in the time-tested, permanent old-master technique of "fat over lean"—meaning starting a painting with a lot

These are my palette cups at the beginning of the day, clipped to my palette.

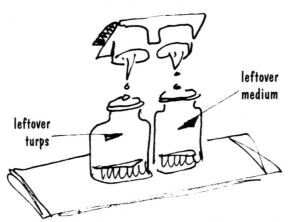

At the end of the day, I save my turps and keep any old oil medium for dumping at the toxic waste disposal.

of turpentine (or turps substitutes, if you're allergic) and getting increasingly thicker and oilier as the painting nears completion.

Storage Bottles. I store mediums and turpentine mixtures in old (clean) mayonnaise and jam jars that have rubberlike plastic in the jar covers, which makes a good seal and effective coating against rust. I also use old brown glass prescription bottles with black screw-caps. The covers are also coated with a rubberlike plastic inner seal. These small prescription bottles are excellent for traveling and smaller quantities of medium because they're small. When I leave town I take along an extra bottle in case one breaks.

PRIMING THE SUPPORT

Impasto texturing may begin long before the actual painting takes place, with the preparation of the prime coat and grounds. I'll discuss the materials for cutting, abrading, and texturing pressed wood panels (canvas and paper have to be handled more delicately). Then I'll show you how I prepare grounds having a variety of textures and a multicolored surface. The emphasis will also be on permanency since these supports will be carrying your overlying oil impasto paintings for many, many years to come.

I prepare lots of panels and canvases in advance so when I need one for a particular painting, I have lots of panels of different sizes, with different types of grounds and textures, from which to choose.

Masonite. One of my favorite painting surfaces (also known as a "support") is a properly prepared Masonite panel. I use only untempered Masonite, which I buy in full 4 × 8-foot (1.3 × 2.1 m) sheets, ¼-inch (.6 cm) thick. Dented or broken corners are not acceptable (as I advise the lumberyard before delivery).

There are two basic plans

I use for cutting the 4 × 8-foot Masonite sheet (as shown in the illustrations). With the first plan, my supplier makes three cuts, so I get three pieces 16 × 48 inches (41 × 122 cm) and one piece 48 × 48 inches (122 × 122 cm). I then make the smaller cuts by hand, ending up with 22 panels. With the second plan, I have four 20-inch (51 cm) cuts made initially, giving me four pieces 20 × 48 inches (51 × 122 cm) and one piece 16 × 48 inches (41 × 122 cm). Then, following the diagram, I make the smaller cuts, ending up with 13 panels.

To make these cuts, I work outside in the shade, sawing with a D-8 crosscut saw in the space between two work tables of the same height. I keep my back to the breeze and always wear goggles and a nose mask while sawing, sanding, or filing the edges to avoid breathing in any dust. (This is important!)

Once the cuts are made, I rasp all the edges—first on the good (smooth) side, then on the reverse side—with a 12-inch flat bastard file. Then I sand each panel horizontally with coarse sandpaper, using my hands rather than a sander and keeping a light touch. I dust off the panels with a clean terrycloth towel, then sand in a vertical direction, giving it a final dusting when I'm finished. Sanding opens up the pressed surface so that later on the priming will be able to get a good hold on the support. Then I go over each panel with fine sandpaper, hand-held, to make sure there are no ragged edges or corners, and dust it off with a clean towel. Finally, I cover my work ta-

bles with plastic, don rubber gloves, and quickly wipe off all the panels with denatured alcohol. Then I let the panels dry for two hours.

Wood Panels. Wood panels have been used for centuries as a support for oil paintings. They're perfect substitutes for Masonite panels because you can have them cut to size by a carpenter or lumberyard, thus avoiding the danger of breathing the dust when working indoors. Also, the sturdiness of the wood eliminates the danger of broken corners if the panels are dropped (which may happen with Masonite—*after* you've painted on it).

I often use solid mahogany panels and have the lumberyard taper or chamfer all four sides on the back to provide a recess for nails. You can also use a top grade

Two basic plans for cutting ¼" × 4' × 8' untempered Masonite (sizes noted in inches).

of plywood in ¼- or ½-inch thicknesses, have them cut to size by the lumberyard, and—while you're at it—ask them to bevel, rasp, and sand the edges to eliminate the sawdust and mess of doing it yourself. Should you decide to cut the panels yourself, however, be accurate and get them perfectly square. Allow ¹⁄₁₆-inch on all sides for your sealing coats and primer and try not to inhale the sawdust.

Canvas. For paintings 20 × 24 inches (51 × 61 cm) or smaller, I buy Utrecht Belgium linen 66J, a smooth single-ply linen, and mount it on standard 1⅝-inch (4 cm) wide stretcher strips. For paintings larger than 20 × 24 inches (51 × 61 cm), I use a medium double-ply linen, Utrecht 74D or no. 950, and mount it on extra-heavy 2¼-inch (6 cm) wide stretcher strips. I also use Claessen no. W13 double-primed Belgium linen (available in 54- and 82-inch widths), Fredrix Irish linen (D. P. Kent) and Spanish linen (Galician), and Winsor & Newton's Winton.

To make sure I don't waste any canvas, I plan how I'm going to cut the roll of canvas in advance. (The illustration here shows one possibility.)

Paper. Panels and canvas are not the only support I use for oils. I also work on paper, on top of "failed" watercolors done on 300-lb 100 percent rag cold-press watercolor paper, or use the discarded centers of museum boards left over from matting my watercolors. The matte surface of the paper gives the oil paint the appeal of a pastel, but the oil surface is more abrasion-resistant than pastels, of course.

To prepare the paper for oil painting, it must be sealed with shellac and primed with flake white paint. Since white shellac must be fresh, I purchase a pint in the spring (when home painting activity comes to life) and mix it with denatured alcohol. I store the mixtures in clean

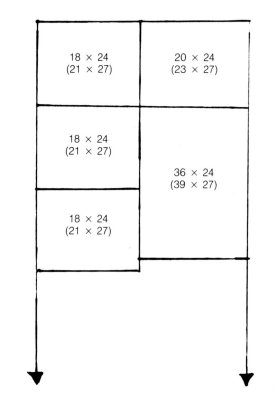

A basic plan for cutting two yards (61 cm) at a time from a six-yard (183 cm) roll of canvas 54 inches (137 cm) wide. Note: allowing 1½ inches (4 cm) per edge for stretching the canvas adds a total of three inches (8 cm) to each side. Actual cut sizes appear in parentheses beneath the finished, stretched size. All dimensions are given in inches.

sealed jars labeled with the last date they can be used. (Shellac can only keep for three months.) I make up two different batches of mixtures, each resulting in a different painting surface.

Sealing Mix No. 1. One-half cup white shellac and 2½ cups denatured alcohol—to be brushed on in *five* saturating coats.

Sealing Mix No. 2. One-half cup white shellac and 1½ cups denatured alcohol to be brushed on in *three* saturating coats.

Abrading the Support Surface. I texture canvases *after* the gesso coating has been applied, sanding between coats of gesso or after the second coat is dry. But I texture the Masonite or wood panel before I apply the gesso. Depending on the material selected, you can get a variety of textures. A fine sandpaper creates a subtle, delicate texture with

sufficient tooth to hold the paint; a medium sandpaper cuts into the surface more heavily, while a rough-textured no. 36 aluminum oxide production paper really cuts into the surface. I also use a 12-inch (30 cm) bastard file with a handle for rasping the panel edges after the Masonite is cut to get off the rough edges, and I use a wallpaper hanger's brush in applying the prime coats of oil paint or gesso. I cut off the front row of bristles with Wiss "Aviation" metal shears, cutting down to the wood, removing the bristles in the second row to give me three different widths of bristles, then saw the brush handle into three pieces and sand the edges smooth. You can see one of the sections, with 1¼-inch (3 cm) trimmed bristles, in the accompanying illustration of my materials. I also use a wire bristle brush to flesh out the soft pulp in the center of the woodgrain panels for an interesting tex-

ture, and use the metal scraper that is attached to the wire bristle brush to distress the wood by giving it a few light swipes across the grain. Then I dust off the residue of dust with a cloth and denatured alcohol before applying paint to the abraded surface.

Before applying my prime coat, when working in the tropics, I work with a treated (Wolmenized) wood and seal it on all sides and edges with white shellac to prevent the green-staining chemicals on the treated wood from bleeding through to my paintings. I use only fresh shellac and apply it on dry (not humid) days, using three or four coats and allowing each coat to dry for about two days before applying the next.

Priming with Acrylic Gesso. You can prime supports with acrylic gesso (I use Liquitex) or with the traditional flake white gesso. When I use acrylic gesso, I work on the untreated linen canvas directly. I cut up an entire roll of canvas at once, put it on various size stretchers (tightly stretched), and dilute the first coat with distilled water, about two tablespoons to a pint of gesso. Then I apply the second coat the following day straight from the can. (Incidentally, it's not necessary to apply acrylic gesso over canvas that has been sealed with rabbitskin glue. In fact, if I use acrylic gesso, it is *instead* of the glue since it acts as sealer *and* primer.)

I like to use Liquitex gesso because it provides a good matte finish. As I paint I take care to avoid any buildup of paint or lumpiness along the edges, as this will make it difficult later to fit the panel into a frame.

For horizontal paintings—landscapes or seascapes, for example—I apply the first coat of Liquitex gesso (barely diluted) in the shorter, vertical, direction. After this coat has dried for at least a day, I apply the second coat of undiluted gesso horizontally, taking care to avoid

wavy strokes. If, however, I'm preparing the ground for a portrait or a vertical still life, I apply the horizontal coat first and the vertical coat second. Why? Because the second, undiluted coat tends to dominate—and that can be important since it reads through the paint.

Priming with Flake White. This is the traditional method of priming canvas or panels and it is more time-consuming than acrylic gesso, but you may prefer it. (Try both ways.) This time I begin work over canvases that are very loosely stretched—not taut as before. The rabbitskin glue will tighten them considerably as it dries. I seal these canvases with two coats of rabbitskin glue (Utrecht linen makes a good one), following directions on the package. When it is dry, I'm ready to begin priming the canvas with flake white.

When the glue is dry, I brush on a layer of flake white paint that has been thinned either with pure gum spirits of turpentine or with a turpentine substitute like Weber's Turpenoid or Shiva's Signa-Turp. (Working indoors, pure turpentine causes me to sneeze, so I use turps substitutes. But whenever the weather permits, I try to prepare my canvases outdoors so I can use regular turpentine.)

For base coats, I only use flake white—not titanium/zinc or zinc whites alone—and only linseed oil base. For impasto paintings larger than 20 × 24 inches, I select only a heavy-weight, double-primed canvas or panel to prevent cracking from mishandling or other abuse. For stiff, sharp-ridged impasto striations, I use either Winsor & Newton foundation white or Grumbacher pretested flake white in a two to one mixture with Shiva Signature underpainting white, making a shallow trough in the drier Shiva white and adding a few drops of turpentine mixture no. 2 to it before whipping the whites together.

A reminder: Seal the back

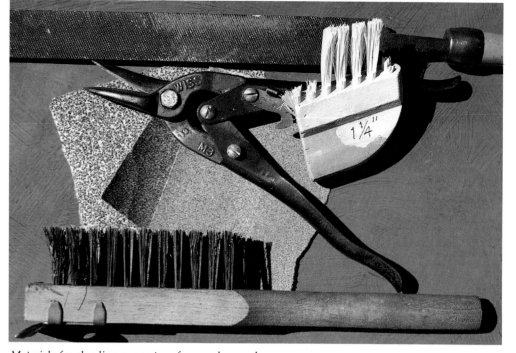

Materials for abrading support surfaces and grounds.

and sides of your panels as well as the front with prime white paint. If you only seal one side, the panel will warp and twist with the pressure as the prime coat dries. This advice holds for acrylic gesso as well as flake white prime coats. In priming canvas, you may also wish to gesso the sides to prevent raveling of the fabric, though it is generally not necessary to gesso the reverse side of the canvas because the weave is thin enough for the rabbitskin glue or acrylic gesso (depending on which you use) to penetrate the weave and stabilize the fabric.

Brushes for Priming. For priming large panels or canvases, I use 3-, 2-, or 1½-inch brushes, while panels under 24 inches (61 cm) can take 1½- or 1¼-inch (3 or 4 cm) brushes. Many types of brushes are available in hardware or paint-supply stores. You can use white hog bristles, red oxhair, or black nylon. All are good. I keep these brushes clean and reserve them solely for priming. And when they get old and beat up, they get even better with wear and tear. In fact, I break in a new brush right away by rubbing

it against coarse sandpaper wrapped around a flat stock the same width as the brush, stroking it from 500 to 1000 times per side.

HANDLING WHITE PAINT

I use many brands of whites. I like a mixture of titanium and zinc (already combined by the manufacturer) for regular painting—to mix with other colors—and for combining with flake white. I use many brands: Grumbacher Superba white, Liquitex, Utrecht, Permalba, Rembrandt, and occasionally Blockx and LeFranc & Bourgeois.

I also use many types of flake whites—for example, Winsor & Newton foundation white, Grumbacher flake white, and Fredrix flake white. The latter comes in a red can and sometimes requires additional mixing by hand, but it's well worth the effort as it makes a good round-ridge ground. Winsor & Newton's flake white no. 1 is extremely stiff and dry, with the texture of pear flesh. Any of these flake whites can be used for grounds—alone or mixed with one of the titanium/zinc

whites. They can also be used later, mixed with other colors as you paint for a faster drying time and a drier-looking texture. Flake whites impart a harder final finish to the paint than the titanium/zinc combination.

I have discussed a variety of whites not to confuse you but to encourage you to experiment with many whites, all with different handling qualities and appearances. When you become familiar with these qualities you'll be able to select the best one for the job or vary them within a single painting for a variety of treatments. To my way of thinking, using the same white over and over again is like playing only one musical instrument when you have an entire symphonic orchestra at your disposal. Why just play Chopin when there's Beethoven and Brahms, Gershwin, or the Beatles? Be creative with impasto!

Removing the Oil. I buy large tubes of white, six at a time, and store them cap-up for as long as eight months. After the paint has been standing for a while, the oil collects in the top. You can work the oil back into the paint by squeezing and

Instructions for whipping whites:

1. For thick whites, soak out the excess oil first on a brown paper bag. Here the brushmarks show prominently in the brown-tinted paint.

2. I put a few drops of my turpentine mixture into the troughs of white paint.

3. At first the whites curdle and resist mixing, so I add a drop more of the turpentine mixture.

4. The mixture looks like this after whipping and scooping it 100 times.

5. The mixture on the left is too soft to hold meringue-like peaks; the texture on the right is good for stippling.

6. After 10 minutes, the evaporated mixture holds meringue-like peaks and I can use it.

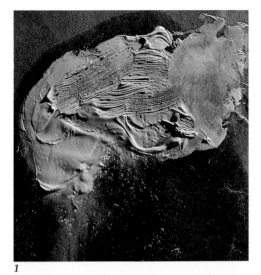

1

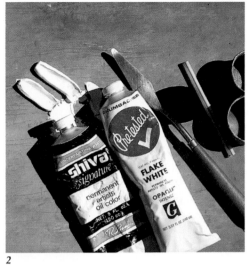

2

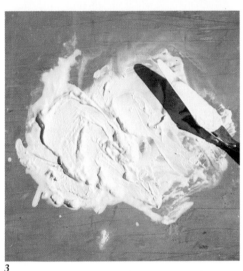

3

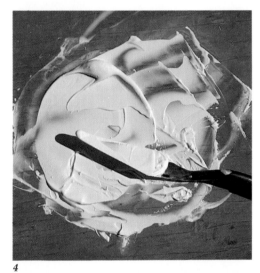

4

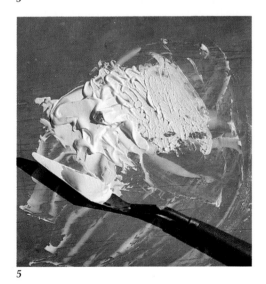

5

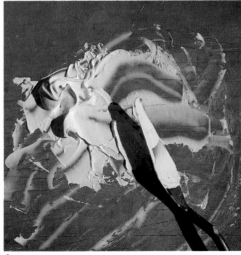

6

kneading the tube of paint back and forth, remixing it to its original state. But, particularly with whites, I often pour off the linseed oil (saving it for future use in a small glass bottle) to get a head start in mixing dryish white paint. In that case, I'll use less underpainting or foundation white in the mixture. Removing the excess oil lets me (and not the paint manufacturer) control the amount of oil in my whites since I can always add more later as I work.

After pouring off the excess oil, there can still be a lot of oil left in the tubed white paint. So I squeeze my flake white (Winsor & Newton brand—the Grumbacher brand is drier and doesn't need this step) onto a brown paper shopping bag and let it drain for about fifteen minutes. Incidentally, I avoid using paints mixed in safflower oil, preferring the traditional linseed oil as a base.

Whipping Whites. Any oil paint can be made more buttery by adding linseed oil to it—there's no magic in this. But I often prefer to make whites drier in order to get thicker impasto effects. To do this I "whip" my white paint with a steel palette knife. I use a Winsor & Newton painting knife with a 2¾-inch (7 cm) blade and an offset handle (see photo). It has a springy resilience and a point that turns up slightly like a hockey stick so it doesn't interfere with my knifestrokes.

I start with flake white (or underpainting or foundation white) and mix it alone or in combination with a titanium/zinc white. Working in the center of my palette, I squeeze out a dollop of white, then form it into a trough with the knife, drop a bit of turpentine mixture into the center, and start mixing. After about fifteen strokes, the mixture is curdled-looking—lumpy, stringy, and difficult to blend—but after about 100 whips, the whites are well mixed and stand in peaks like meringue topping. You

can see my step-by-step mixing process in the accompanying photos.

Fredrix flake white, in one-pound cans, is perfect for soft-ridged strokes. If the linseed oil has settled in the can and risen to the surface, I pour off most of the oil into a clean glass container and pound the paint with a long-handled screwdriver to break the flake white into large pieces, then smaller bits. Then I switch to a flat-ended stick and mash the bits, adding a little linseed oil, until it is roughly mixed. (I keep some of the linseed oil in reserve to gauge the right degree of paint thickness I want.) *Twin Farmhouses* (page 86) is painted on this surface. Finally, I put the mixture through a sieve to take out the larger pieces of paint (only for the first coat—the second one can be thicker), and brush it on horizontally.

The first coat of flake white is thinned with turpentine to the consistency of cream and is thin enough to let some of the Masonite or panel color show through. I let it dry three days, then hang it up out of direct sunlight in a well-ventilated area for about two weeks, dating each painting on the back. Then I apply the second coat of flake white. This can be the consistency of mayonnaise and occasionally even heavier, like meringue—with firm peaks that don't collapse at first. (However, after a while, they fall off, giving the surface a nice, soft, randomly brushed texture.) Then I set the panels out to dry in a sheltered spot free of dust, insects, and anything else that might disturb the wet paint. Depending upon the thickness of the second coat, I allow about two weeks for an untextured layer to dry; a month for a more textured one; and about three months for a really thick coating. To be sure the grounds are dry before I paint, I poke a nail into a thick area at random, pressing hard. If it doesn't leave a mark, the painting is dry.

Incidentally, flake white is

toxic. Be sure your ventilation is good—a fan as well as an open window. And don't eat or smoke while painting. To be sure all paint is off my hands, I wash them twice!

PREPARING TEXTURED AND COLORED GROUNDS

The key to preparing textured and colored grounds is variety. A beautifully toned ground with an interesting texture is inspiring to work on, and this excitement is bound to be translated to your painting as you work. I get textures into the grounds in a number of ways. Sometimes it's by brushing with interesting and random strokes, or by evenly stroking the brush in one direction or with a cross-grained, crosshatched appearance. Sometimes I may stipple the paint with a painting knife or apply the paint with a roller.

Texturing with Beach Sand. I occasionally work beach sand into my painting grounds for additional texture. Of course, I clean the sand well before using it by rinsing it several times in distilled water, boiling it for about 15 minutes in more distilled water, and drying it out in the hot sun, then bottling it in a clean mayonnaise jar.

Building Toned Grounds with Palette Leavings. Rather than throw away perfectly good paint left over from a painting session, I save it to use in toning grounds. This paint, with most of the oil removed, is then lightened with enough white to create a nice tint (I base the value on pastel papers). I then brush it onto supports with a Mussini no. 9 flat bristle brush in thick, uneven layers.

I'm selective in choosing certain colors—nothing dirty, though gray colors are welcome. And I'm careful to avoid all thin or runny mixtures, choosing only rather dryish paint, without too much medium.

I generally pick up the mixture with my Mussini no. 9 flat brush and wipe (or brush) it onto the canvas. Then I pat it for a stippled effect. (Incidentally, palette knife stippling is done the same way as with a brush. Only the feel is different. Trying your palette knife is well worth the new effect.)

If there's enough leftover paint to cover a large segment of the painting ground, I'll mix up a fresh batch of paint to match the quality of the impasto I just collected. At other times, when there's only enough paint for a small section, I paint only a small patch and set it aside to add to later. I'm especially careful not to use anything muddy. Only fresh color excites me.

It's important to remember that this texturing of the ground is a gradual process. It may take as long as a week to dab on the right amount and colors of impasto, and maybe a month before I'm satisfied with the amount of impasto buildup on the surface.

As for the permanency problems involved in adding bumps and nodules from my palette leavings, I noticed several Monets that have the appearance of paintings done over old previous works of art on canvases, which may be sufficient precedent for my own ground preparation. And, as for the dry quality of my paintings, I also have the "backing" of the masters: I frequently notice dry surfaces in the Bonnard and Monet paintings I see in museums.

I generally try to cover the entire surface of the support since it seems to be a more permanent procedure. So I was shocked to see several Bonnards with bare canvas showing. This seems to be a particularly dangerous practice in terms of permanency because of the number of acidic pollutants around that can erode or deteriorate a painting. And even though some Cézanne canvases contain some exposed areas, I would hardly condone the practice.

All my techniques are, to the best of my knowledge, permanent and technically sound. In all my years of painting I have never had a painting crack. Even *Vermont Winter Houses* (page 124), painted in 1956, is still free from cracking, flaking, or peeling despite its thick impasto. I am also careful to store paintings in moderate household temperatures and out of extremes of hot and cold, which aids in making them permanent.

24 WAYS TO VARY YOUR GROUNDS

To give you an idea of the variety of surfaces it is possible to create, I've prepared a series of photographs showing details of some of the many grounds I've created in the past. Details of their preparation are provided below, with numbers for easy reference.

1. Plain textured ground. The Masonite surface was roughened with medium-textured sandpaper, then Grumbacher flake white was applied with a roller. After drying for two weeks, it was sanded with fine sandpaper and a second coat was applied, again with a roller, and the panel was cured for a month.

2. Untextured ground, stroked in one direction. The Masonite surface was sanded, then Grumbacher flake white was brushed on in a single direction and left to dry for three weeks. I use horizontally grained panels for landscapes and verticals for florals.

3. Cross-grained untoned ground. After fine-sanding the Masonite, it was primed with two coats of Grumbacher flake white. The first coat was applied vertically, the second horizontally, and it was cured for two weeks between coats, and left to dry for a month. Then a light gray tone was rubbed on with a soft piece of terrycloth towel and it was left to dry for a week.

4. Beautiful surface for fine, thin, detailed impasto work.

The panel was first sanded with fine sandpaper and dusted carefully, then brushed with flake white paint (oil removed) to which a teaspoon of turpentine and a drop of linseed oil had been added. After curing for two weeks, it was then sanded lightly with fine sandpaper. This was followed with a coat of gray paint prepared on a brown paper bag to absorb the excess oil. The paint was a mixture of cobalt blue, raw umber, and Winsor & Newton foundation white (oil removed, mixed well, with just a touch of yellow ochre), mixed on a brown paper bag to absorb excess oil. The gray tone was applied with a fine, soft, white house painter's bristle brush, left to dry for another two weeks, sanded, given a second coat, let dry for two more weeks, and then sanded again.

5. Stipple-textured ground with an extremely fine pebble finish. This ground, which provides an adhering base for detailed realistic impasto work, was begun with a coat of flake white applied over a free-brushed, fine-grained sandpapered base, and dried for two weeks. It was then covered with a tone mixed from cadmium orange and Naples yellow, scraped across the surface with a ¾-inch long palette knife blade, allowed to set for twenty minutes, then patted gently for a fine pebble finish and dried for a month.

6. Freely brushed green-toned ground. Working over a fine-textured cross-grained flake white prime coat (two coats), cured for a month, with a freely brushed mixture of permanent and viridian greens, thinned with turpentine mixture no. 1, applied in a single shot without going back over it.

7. Raw sienna toned and textured ground. I began with a seasoned panel that had been abraded with a wire brush and razor blade scratches. Then two coats of randomly brushed flake white were applied, dried,

1

2

3

4

5

6

and sanded with fine-grit paper, and cured for a month. Finally raw sienna thinned with turpentine mixture no. 1 was rubbed over to look something like wood-grain, and the support was cured for another week.

8. Turpentine drizzled over freshly painted gray impasto. This ground provides an unusual texture for an *alla prima* painting. The tone was applied over a fine cross-grained flake white ground, then cured for a month. (See *Blue Balcony*, page 94).

9. Transparent double-layered ground. First a gray tone thinned with turpentine mixture no. 1 was scrubbed on with the side of a no. 9 Mussini brush, allowing plenty of the horizontally primed flake white ground to show. Then a second layer of terra rosa (you can also use Venetian red), with the oil removed, was rubbed on lightly with a clean piece of towel. (Shown here partially finished.)

10. Triple-layered transparent ground of glazed primary colors. This ground was applied over a freely brushed, well-cured, double-coated flake white panel. I began by brushing Naples yellow over it, let it set for thirty minutes, then gently patted the paint with the flat side of a no. 9 Mussini brush and let it dry for a week. Then a second coat of pale neutralized cerulean blue thinned with turpentine mixture no. 2 was brushed on vigorously and let dry for two days. Finally, just a dusting of terra rosa was rubbed on, partially rubbed off with a fresh piece of toweling, and cured for a month.

11. Very subtle and soft, ridge-textured ground of acrylic gesso. The texture was brushed on with a coarse brush and two or more coats of Liquitex gesso thinned with one or two tablespoons of distilled water to a cup of gesso. The ground coat was brushed horizontally first, then vertically, with a fine-haired brush, and cured for one week. Then a pink earth-toned ground made

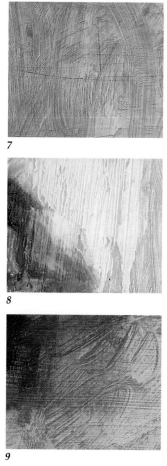

7

8

with a mixture of cadmium red and orange, Naples yellow, and flake white thinned with turpentine mixture no. 2 was rubbed over the white ground with a rag.

12. Soft round-ridged ground of flake white gesso and raw sienna. This time the soft round ridges were made with Fredrix flake white (in a red can). I left a few specks of the flake white unmixed for additional texture on the rough-brushed striations. This heavy coat of flake white over sanded Masonite had quite pronounced peaks, but they settled down to these subtle round ridges. After curing it for one month, I rubbed on raw sienna thinned with turpentine mixture no. 2, with a rag.

13. Flake white ground rubbed with a pink earth tone. This is the same prime ground as the preceding example, a single heavy coat of Fredrix flake white applied with a coarse brush and cured one month. Instead of raw sienna, I rubbed on a pink earth mixture, the same one used in no. 11, with a rag.

14. Sharp ridge, ground textured with brush and knife. This crisp, ridge-textured ground is made with Grumbacher flake white. The paint was set out onto a paper plate to soak out excess oil for twenty-five minutes, thinned with a bit of turpentine mixture no. 1, then applied with a 3-inch nylon bristle house painting brush held vertically. This mixture holds a sharp brushstroke. I let it set for twelve to fifteen minutes, then stroked the ridges with a 2¾-inch long painting knife, applied deftly in single touches. After a month, I checked it to see if there were enough small "breathing holes" to break up the surface of the knifemarks. If not, I sanded the surface, then rubbed on Venetian red thinned with turpentine mixture no. 1 with a rag.

15. Sharp-edged, double-primed textured ground. This was done with Fredrix flake white for the first soft-

9

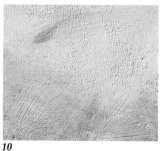

10

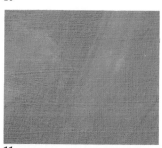

11

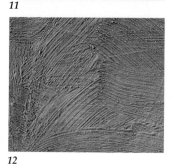

12

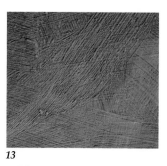

13

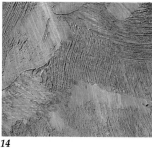

14

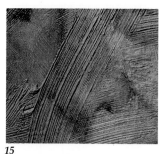

15

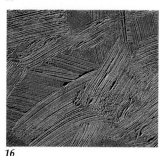

16

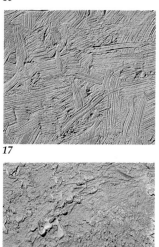

17

18

ridged coat, followed two weeks later with Grumbacher flake white for the second coat, as in no. 14. After curing it for a month, Venetian red and a touch of turpentine mixture no. 2 were rubbed on with a rag, then it was cured another two weeks. This ground is similar to the one in *Mr. Page* (page 106).

16. Sharp-edged randomly brushed texture on a triple-coated ground. The first coat, brushed on horizontally, was Grumbacher flake white thinned with a bit of turpentine mixture no. 2. It was cured for two weeks, then coated again with the same mix brushed vertically, then dried for a month. The third coat is a mixture of Grumbacher white plus terra rosa, cobalt blue, and Naples yellow, with a touch of turpentine mixture no. 2 with a drop of stand oil. Before the paint was applied, I set it out to dry for thirty minutes on a brown paper bag. When it was stiff as pudding, I applied the paint as a third coat and cured it for two months.

17. Hard-edged, randomly brushed, textured ground. The panel was prepared the same as the preceding example, but the final brushwork is a rich mixture of Winsor & Newton foundation white and Rembrandt Naples yellow, thinned just a bit with turpentine mixture no. 2, placed first on a brown paper bag to set to the point of a stiff meringue consistency, then brushed on with relish!

18. Randomly brushed multilayered ground, stippled with a knife. This is a combination of several layers of palette leavings applied every other day in order to let some of the thickness firm. The layers were patted with a painting knife or thumbed to create a smudged look, or both. I even mixed some sand with the paint at the lower left. *Waterville Barns* (page 108) was painted on a similar ground, first left to dry for a month before being used.

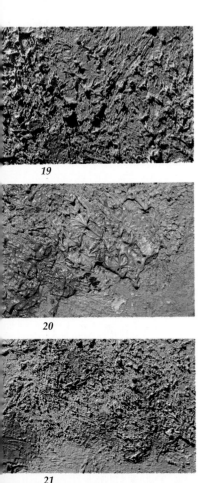

19

20

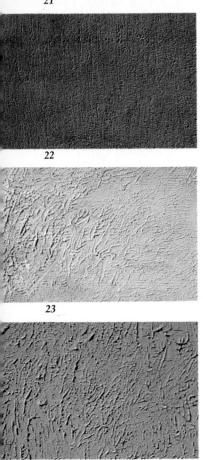

21

22

23

24

19. *Heavily stippled ground with sharp peaks.* This ground was patted and stippled with a 2¾-inch-long painting knife. The meringue-like peaks were left sharp so that the actual painting would get a good grip on the support. I used a similar base, with slightly rounder peaks, in *Ramo del Forno, Venice* (page 110).

20. *Thick-textured stippled and toned ground.* This heavy coating of palette leavings (though under ⅛ inch thick) was applied on top of several considerably thinner layers (see bottom right corner) and seasoned for two months.

21. *Stippled ground with sand added.* This stippled ground was worked over a light pink earth tone, followed by a brushed-on gray layer, with a couple of patches of gray-blue and olive green added. The final coat was mixed with beach sand. The texture is similar to the sky area in *St. Tropez Tower* (page 112). (The balance of that painting was done on a sharp-ridged ground.)

22. *Fine-stippled, vertically textured ground.* I began with a double-primed flake white on a panel, cured it a month, then coated it with a brushed-on thin impasto of gray-green earth thinned with a touch of turpentine mixture no. 1 and cured a week. When it was dry, I brushed on a thin coat of cadmium red/flake white (pink) and cadmium orange/flake white (pale orange) in a two-color split surface, let it rest 20 minutes, then rolled the surface with a small rubber brayer or a 1½-inch (4 cm) cardboard cylinder covered with plastic wrap or aluminum foil, and cured it for a month.

23. *Stipple and knife indentures on a semi-fine ground.* I worked on a double-primed fine-quality cross-grained white-primed panel. After curing it, I brushed on a creamy pale earth green and let it rest 15 minutes. Then I rolled on a few thin touches of Naples yellow reddish extra, let it set ten minutes, then patted it with a Lang-nickel X-18 painting knife with a 3¾-inch-long (10 cm) blade. Only a single patting was needed in order to raise this fine stipple over the entire surface evenly. After resting the paint five minutes, I drew some small indentures diagonally across the two-color stippled texture with a small 1½-inch (3 cm) painting knife and then left it to cure for a month.

24. *Sharp-peaked, small-stipple-textured ground prepared with alkyd white paint.* I sanded the panel and gave it two coats of Sani-flat (Benjamin Moore) alkyd white primer, waiting a week between coats and seasoning it for two weeks. Then I prepared the toned ground: a mixture of Grumbacher flake white and Permalba in a one to two proportion, and whipped it together with a few drops of turpentine mixture no. 2, then added touches of Naples yellow reddish extra and raw umber, plus a bit more turpentine with a drop of stand oil, whipped it again, then let the paint set on a wood palette. When its consistency resembled heavy cream, I brushed it on with a Mussini no. 9 flat bristle brush, let it set five minutes, then patted it with a Langnickel X-18 palette knife. After curing for three months, this ground will be hard as a rock and will give an excellent "grab" to the paint.

BUILDING UP A TEXTURED GROUND ON MASONITE

The six examples on the right are taken from a single ¼-inch (6 mm) thick Masonite panel that was first primed with two thin coats of flake white, allowed to dry for two weeks between coats, then cured for a month. The prime was applied vertically, then horizontally, for a cross-grained texture that would help future layers to adhere. At first the coats were quite dry; subsequent coats had slightly more linseed oil added.

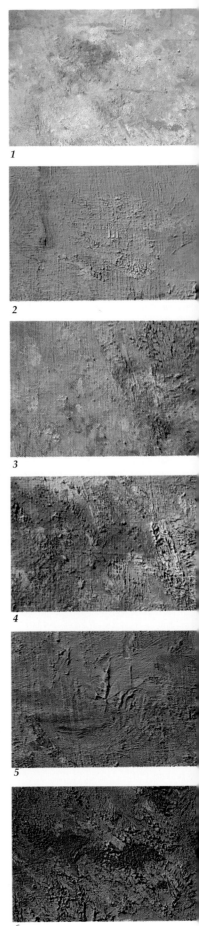

1

2

3

4

5

6

1. *View of the entire 12 × 16 inch (30 × 41 cm) panel showing toned surface.* The colors were accumulated gradually over a period of one month, with paint applied every other day. Sometimes I used mainly leftover flake white and colored it with a small amount of cadmium red for a pink tone, or with a bit of Naples yellow and flake white added to the pink for a pale orange-pink.

2. *Detail showing initial tone of terra rosa.* After priming the panel, I scrubbed on a thin pale mixture of terra rosa thinned with turpentine mixture no. 1 with a rag.

3. *Second and third layers of tone (detail of left corner).* The next layer of orange, green, and lavender brushed over the terra rosa ground color can be detected at the left. Then I brushed on some heavier dryish impasto a few days later, after the surface was dry. You can see this at the top right.

4. *Detail showing addition of more colors.* In this detail you can see that pale orange has filled the terra rosa cross-grained ground, then lavender pink is the next layer, raw umber and white is the following layer—stippled on with the flat of the brush.

5. *Detail of top center showing palette knife work.* Pink and yellow ochre were brushed on, then troweled and stippled, moving the knife left to right. Note each layer overlapping the previous color: olive green, thin light lavender, light green, yellow. The colors retain their individual identities because each is dry before the next layer is applied.

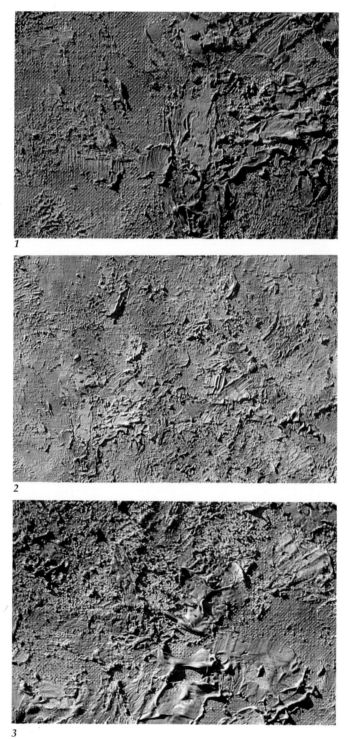

1

2

3

6. *Detail of lower right corner showing stippling.* This detail shows the layers of cream white, then light brown earth stippling, done with a knife. I think Monet must have built up the paint in his Rouen Cathedral series like this. I've used this amount of texture on a ¼-inch (64 mm)-thick Masonite surface, but I'm chicken to try it on a stretched canvas over 20 × 24 inches (51 × 61 cm) for fear of the paint cracking or flaking off.

BUILDING UP IMPASTO ON CANVAS
The last details show a 12 × 16-inch (30 × 41 cm) linen canvas primed with flake white then rubbed with a tone of terra rosa.

1. *Detail of the canvas texture.* Note how the texture of the canvas shows through the impasto even at the end, creating a different look from the preceding examples done on Masonite.

2. *Detail of the underlying tone.* Notice how, despite the number of layers, the terra rosa ground still shows through in places. I never cover one layer completely with the other, but always make sure the layered quality remains.

3. *Detail of the thick impasto.* Although there appear to be massive layers of thickness here, none exceed ⅛-inch (32 mm) in thickness. The heavy, shiny patch at the bottom of this detail will have to be sanded with rough aluminum oxide production paper when it's dry (after three months). At this point it is too "fat" for new layers of paint to adhere.

2.

PAINTING IN LAYERS

Working in layers, literally building the painting out from its support, is an exciting process. It's as if the painting were growing before your eyes, gradually assuming its own personality. As you'll see from the examples in this chapter, building the painting in layers allows you both freedom and control. It can also help you set up exciting color vibrations and atmospheric effects.

Building on Transparent Washes

In *Pumpkin and Pigeon Peas*, you can readily see the original turpentine wash, as well as a few modest touches of more opaque pigment—the beginnings of impasto—used to emphasize the tin pie plate. This subtle personal touch makes an important contribution to the character of this painting. Had I not added this slight opacity to the pie plate, the painting would have remained an ordinary, undistinguished lay-in.

Doing a simple painting like this can teach you a lot about the basic elements of oil painting. Try using a minimum of pigment, mixed with lots of turpentine, for a loose, watercolor-like wash as you lay in your painting. Your color should be almost as thin as water. Apply it freely, letting it run in drips. If you don't like the results, you can always come back later and change things with opaque paint.

Use color creatively, to make the painting work. Here, instead of painting the pigeon peas green, I mixed white with lavenders and blues. This gave me a more exciting color to put next to the reds and oranges of the cherry tomatoes and the pumpkin. The color of the pumpkin rind is also "invented," but it helps to make this area recede, under the orange. Try to be daring with your color . . . but *think* before you dare.

Also take advantage of happy accidents, as I did with the abstract white shape on the left side of the pumpkin. I hadn't gotten around to painting that area orange when I stepped back to look and liked what I saw . . . so I left it. Can you see

Pumpkin and Pigeon Peas, oil on 12-ounce cotton duck, 20" × 24" (51 × 61 cm)

how this white shape adds zest and direction to the painting as a whole?

I use this painting for teaching purposes, but it has also hung on our kitchen wall for 28 years and is accepted as a finished painting. The stained color streaks of Morris Louis's canvases are no more finished or unfinished than

this painting. Don't feel bound by academic rules or art critics to alter a painting's finish. You are the sole judge of when your painting is finished.

Letting the Painting Grow

To give you a better understanding of the way I build up a painting with layers of impasto, I've included this step-by-step sequence of the development of a still life. As you'll see, I made some major changes in both composition and color as the painting progressed. This is one of the advantages of working in oil—it's easy to alter things if they don't seem right.

Altogether, this painting took about fourteen weeks to do, including a month's "curing" time between my application of the pink impasto on the tablecloth and my overpainting of this area in white. But I didn't work on just this painting during that time. Usually I have several different paintings, in various states of finish, going at once in my studio.

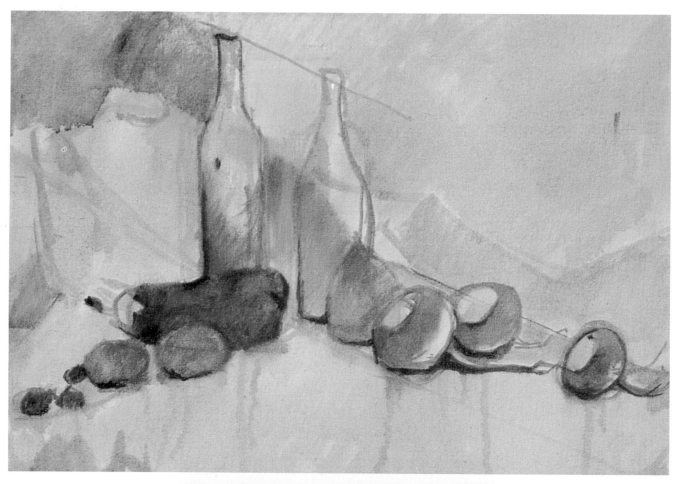

I begin by drawing in my subject with thin washes made with turpentine mixture no. 1. There's just enough linseed oil in this mixture for a good bond with the ground of the panel. Notice the way I massed the objects to unify the composition.

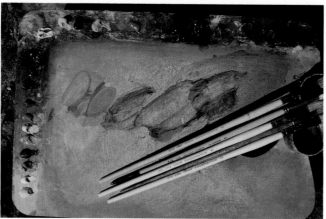

Here you can see the layout of my colors on the palette and the thinness of my turpentine washes.

At this point, I try aligning the vegetables along two arcs, culminating in the necks of the two bottles. Both the geometric design and color treatment are exploratory at this stage.

As I develop the underlying color and geometry, I keep questioning what is happening. Here I begin to feel unsure about the exit between the two bottles and attempt to "stop" it with the dark diagonal patch.

I have already started to build a base of impasto on the turnips in places where I want to emphasize the lights. My whites are Grumbacher flake white and Winsor & Newton foundation white. After removing the oil by leaving them on paper for 20 minutes; I whipped them with turpentine mixture no. 1.

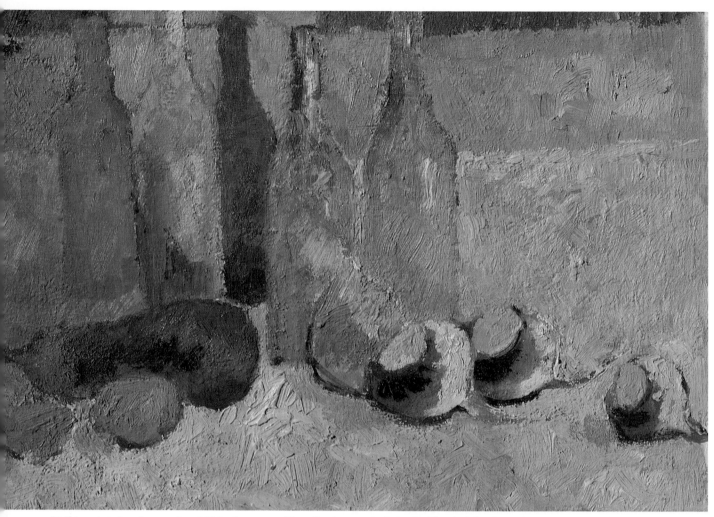

At this point, I make a major shift in the composition. To plug up the hole, I add a dark bottle in the center; then I flank the green bottles with a lavender and a pink bottle. To stabilize all these verticals, I introduce some horizontal bands in the background. I also get rid of the busy geometrics in the foreground, covering this area with a solid pink.

With the direction of the painting firmly established, I concentrate on building up the many rich layers of color and texture. Because I know I want a crusty finish of sparkling light on the turnips, for example, I add thicker and thicker impasto.

The bottles and surrounding background are also slowly growing, acquiring rich color and texture. At this stage, I allow two weeks drying time between layers.

I like to mix my colors on my palette so I won't be surprised by a color that's too aggressive or raw for the effect I want. To keep my colors clean, I avoid overmixing the existing piles of pigment and clear all mixed colors off my palette every half-hour or so.

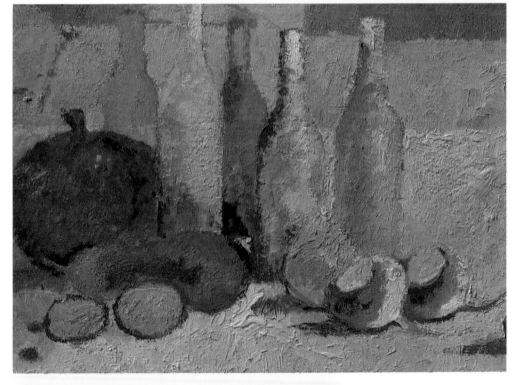

Now I make another compositional change, adding the round pumpkin to alleviate the rigidity of the many horizontals and verticals.

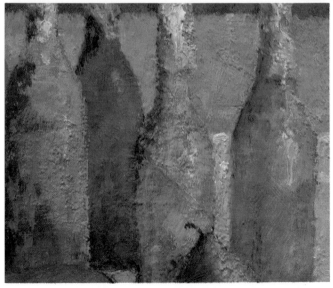

Overpainted

Alla prima strokes

Palette knife edge defining bottle's neck

To represent the aggressive sparkle of the aluminum wraps on top of the Marbi bottles, I use a variety of impasto textures and different colors of white. Marbi, by the way, is a homemade root beer native to St. Thomas.

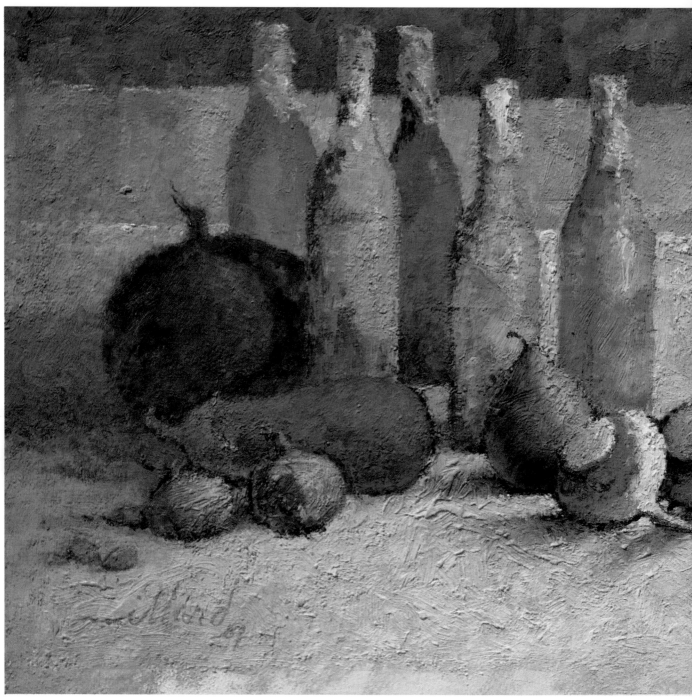

Marbi and Turnips, oil on Masonite, 22″ × 28″ (56 × 71 cm)

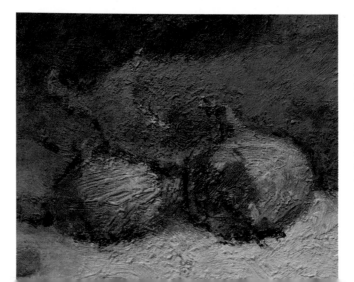

It's never too late to make changes. Looking at the directional gestures of the bottle tops, turnip tails, and vegetable stems in the rest of the composition makes me decide to change the potatoes into stemmed onions. At this point, I also begin to shift the color of the tablecloth from pink to white.

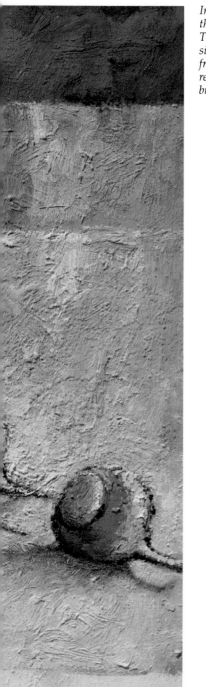

In the completed painting, all the patient layering pays off. This kind of luminosity is not simply a depiction; it comes from within the painting, as a result of one layer of color breathing through another.

Outlining brings objects toward the viewer.

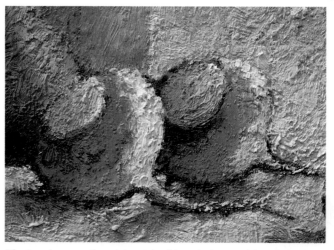

The turnips are a key element in this painting, moving the eye across and back to the bottles and providing a bridge from the foreground to the increasing texture of the background. Here you can see clearly how the protruding bits of pigment catch the light and create a radiant effect. All the different touches of color and paint contribute to the sparkling feeling.

Some of the panel's original white ground is still visible at the bottom of my painting. This "true" white allows me to gauge the transitional whites I layer over the pink. As you can see, there are a variety of whites—some bluish, some purplish, some pinkish.

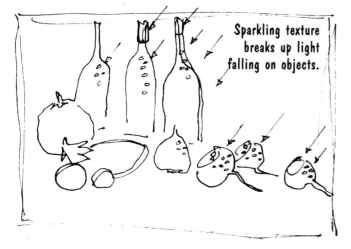

Sparkling texture breaks up light falling on objects.

Keeping Everything in Tune

In developing a painting, I tend to work all over, building everything together so the painting as a whole remains "in tune." No individual object becomes more finished than its companions. This process allows the painting to grow as a whole, almost as a living entity.

This particular painting exemplifies many of the different techniques I use—vibrating edges, thumbed passages, knife-flattened areas, and crusty highlights. In its balancing of contrasts—brilliant versus understated colors, sharp versus soft textures, piquant accents versus quiet transitions—it relates to qualities I admire in classical music. In fact, it was inspired by Brahms's Piano Concerto No. 1, played by Arthur Rubinstein. (I often paint to music.)

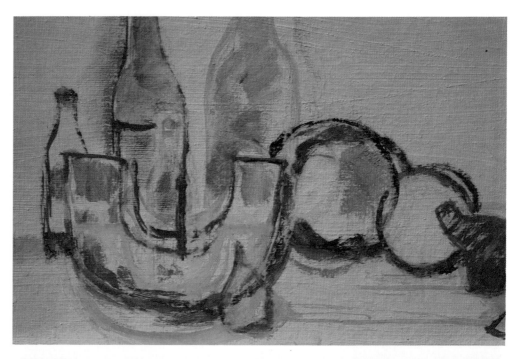

This initial color sketch, done with a Wharton no. 2 brush, shows how I sometimes grope for the "right" arrangement of objects. The first placement of the slice of pumpkin, done in yellow, seems too low, so I revise it, moving from the yellow to the orange then later to the red outline, which now satisfies me.

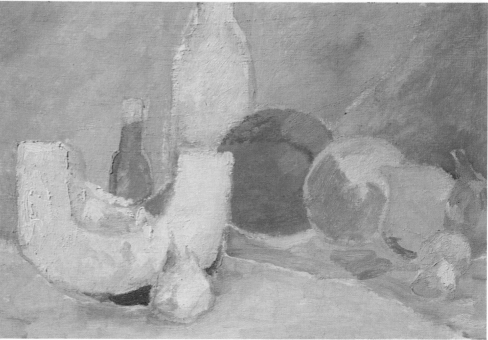

After scrubbing on the local color with an old Mussini no. 9 flat, I begin to build up layers of color. Here I'm already into my third or fourth layer. The pumpkin is taking on a leading role, requiring more attention to the variety and thickness of the pigment. I've changed the placement of the bottles in the background—but I'm still undecided about this.

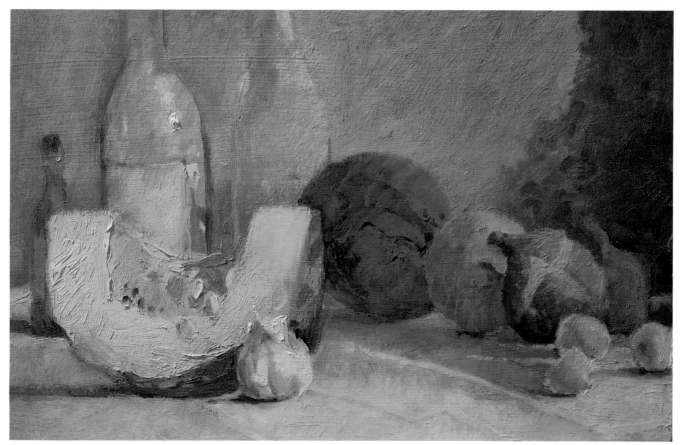

Pumpkin Seeds, oil on Masonite, 9½″ × 14½″ (24 × 37 cm)

The final stage shows several changes: I've added a second bottle of clear glass, outlined in green, and I've moved the Tabasco bottle to the left, where it offers an important contrast in both value and color. Except for the gob of white highlighting the shoulder of the clear glass bottle, I've concentrated my impasto excitement on the garlic, seeds, and pumpkin.

This detail reveals the different levels of impasto and the varying treatment of the edges. Notice how I've used the ridge of pigment to catch and hold the light.

For the whites in this painting, I whip two parts Permalba white (with the oil removed) with one part Shiva underpainting white. This mixture is key in delineating the edges of the seeds and the garlic whiskers; the paint sits up yet still looks fluid. For a contrast to the impasto areas, look at the right corner of the pumpkin, where I have used a palette knife to push the impasto up and off (twisting counterclockwise).

Tracing the Buildup of Paint

You can learn a lot about the way a painting was done by carefully studying the different layers. Sometimes I'll take my magnifying glass to a museum for a close look at Bonnard or old-master methods. The guards are usually fairly good about letting you do this, as long as you don't actually touch the painting. With the floral painting shown here—done on a wood panel—you should be able to count five or more layers of paint. Even from the reproduction, you should get a sense of how the paint builds out toward the viewer, creating a very believable feeling of depth.

Here you can see the initial ground, with vertical strokes over the horizontally raked grain.

For this painting, I chose a mahogany panel with the grain raked horizontally. I brushed on a textured ground with vertical strokes, using a combination of raw umber and Grumbacher flake white with a touch of Naples yellow. My whites for the start of the painting were a mixture of Shiva underpainting white and Grumbacher flake white. After the fifth layer, I used the flake white with a touch of oil medium no. 1. Then, at the very end, I added touches of pure Permalba white.

Initially I laid in the two top pansies with a mixture of cadmium yellow and orange. Then I added some burnt sienna, working wet-into-wet with just a touch of oil medium no. 1. In the background I put in some flat, dry touches of lavender and then added some broken strokes of gray-green.

Now look at the pansy in front. You should be able to detect five layers up to the center of cadmium yellow medium and raw umber with a touch of green. In the blue hyacinths and in the white flowers, you can see four layers. The thickest impasto is in the last layer, bringing the flowers forward, toward the viewer.

Pansies and Hyacinths in a Blue Vase,
oil on mahogany panel, 5½" × 7¾" (14 × 20 cm)

Notice how the strokes of paint add to the three-dimensional feeling of the flowers.

3.

SUGGESTING DEPTH AND VOLUME

By building up layers of paint, you can create the illusion of depth and three-dimensional form on the flat surface of your panel or canvas—on what is referred to as the "picture plane." The first four paintings in this chapter indicate the different kinds of space you can suggest, from fairly flat to more atmospheric. The last two paintings focus more on the buildup of form—making it truly tangible with paint.

Keeping the Surface Flat

I wanted to produce a flat painting, all on the surface, much as Matisse did. Specifically, I wanted to keep the flower and buds on the same plane as the background. Within the posterlike simplicity of this design, the positive and negative shapes take command. Only a speck or two of heavier impasto breaks the flatness to come forward. Yet these minute bits of impasto add an important visual tension, bringing the painting to life.

Lily and Seven Buds, oil on wood panel, 9" × 6" (23 × 15 cm)

To produce the flat, matte finish I wanted, I selected a mahogany panel and primed it with two coats of flake white, applied with horizontal strokes on a vertical grain. After letting this dry for several months, I toned the panel with an orange wash dissolved in turpentine mixture no. 1. I waited three days before sketching in the lily and the buds with a Wharton no. 2 long-bristle brush, using a mixture of cadmium orange, yellow ochre, and Shiva underpainting white. Two days later—using oil medium no. 1 and a palette consisting of Winsor & Newton foundation white, cadmium yellow pale, yellow ochre, raw sienna, cadmium orange, cadmium red deep, Winsor & Newton permanent rose, LeFranc & Bourgeois mineral violet no. 2, and cobalt blue—I tackled the rest of the painting. All the colors

that had a buttery quality, along with the white, were set out on brown paper to absorb any excess oil before I began to work.

Clocking myself for discipline, I painted *Lily and Seven Buds* rapidly, in an hour. To maintain a flat look, I intentionally omitted shadows. Notice that the background is done primarily with vertical strokes, except for the swirling stroke that repeats the curved lily petal in slightly thicker impasto. The overall "grain" created by the vertical strokes then complements the more emotionally painted, multidirectional lily petals. A few touches of thicker impasto in the center of the petals are enough to bring the blossom just slightly forward, distinguishing it from the flat background. And the minute touch of cadmium yellow pale on the lower left bud adds a bit of sunlight.

Bringing the Subject Forward

The feeling of space here is greater than in *Lily and Seven Buds*. I used thicker pigment to make the eye believe that the violets are coming forward, away from the thinner background area. I didn't want too great an illusion of space. By keeping the brushwork fairly evenly distributed over the violets, blue jar, and dish, without too much variation in thickness, I maintained a certain flatness. Everything still seems fairly close to the surface.

My first step was to cover my Masonite panel with gesso, using only horizontal strokes. Next, I painted in a pale layer of cadmium orange mixed with a touch of burnt sienna. This underlying tone was planned as a complement to the greens and purples of the subject. In the finished painting, you can see it showing through in places, adding to the feeling of depth.

For the background, I used a relatively thin impasto, letting it become translucent in spots. In contrast, on the flowers, jar, and dish I used a generous amount of pigment and energetic brushwork. Throughout I used oil medium no. 4, which retains the original texture of the brushstrokes.

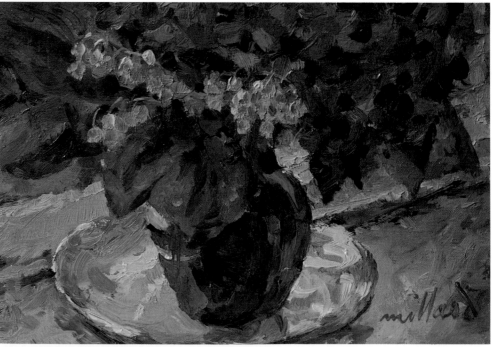

Violets in a Blue Jar, oil on Masonite, 6" × 9" (15 × 23 cm)

Using Three Thicknesses of Paint

Here I wanted to create the illusion that the flowers are sitting in front of and a short distance away from the window. To accomplish this, I used three different thicknesses of pigment on top of the initial ground. The various layers of paint literally build the space out, toward the viewer. It's a simple process, but it works. There is a feeling of atmosphere, of the air in between things.

First I used a wire brush on the wood panel to open the grain a bit, allowing it to receive and hold the priming. After applying two coats of flake white, horizontally stroked, I left it to cure for two months.

When I returned to the painting, I brushed in a layer of cool light gray with thin vertical strokes. I let this sit for about four hours, until the small amount of turpentine in the mixture had evaporated.

Next I sketched in the flowers, using a no. 2 Wharton brush and a palette of cobalt blue, cadmium yellow pale, yellow ochre, and white. After suggesting the stems, I scumbled in the flowers and then placed light touches all over the background, allowing much of the light gray ground to show through. This technique sets up the feeling that you are looking through the loose brushstrokes, further into the background.

Using a thicker impasto mix, I gave the mass of flowers some body. Again, I left unpainted areas, with the original ground showing through, to create a sense of atmosphere.

Finally, I briskly touched an even thicker impasto mix of creamy whites onto the uppermost blossoms, so they seem to catch the light coming through the window. These white accents follow a sweeping arc, offering an important balance to the window's right angles.

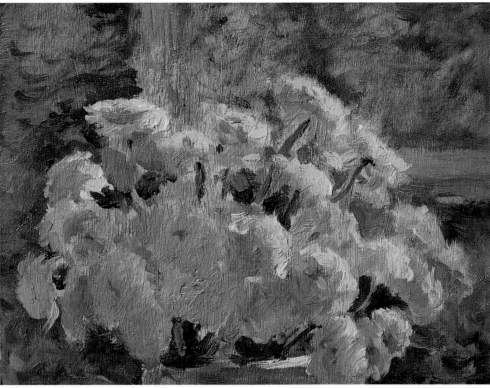

Mums by the Window, oil on wood panel, 6" × 9" (15 × 23 cm)

Penetrating into the Picture

In this painting, I wanted to see how far I could poke into the background . . . "destroying" the flatness of the picture plane. But how could I make the viewer believe he or she was looking *into* the picture? The answer was to use varied thicknesses of impasto. Simply put, thin pigment appears to recede while thick, rich pigment comes forward. In this painting, the prominent lily is literally up front.

I began by coating the Masonite panel with Liquitex gesso, slightly diluted. In applying this coat I left soft horizontal and vertical ridges to simulate the rough weave of canvas. For a ground color, I brushed on a mixture of cobalt violet, cadmium orange, and white. This color is not too aggressive and tends to recede. Then I set everything aside to dry for a week.

To get rid of any excess oil, I set my colors out on the back of a paper plate. In the center I put my Permalba white and Shiva underpainting white, squished rather flat so they'd dry out quickly. Then I mixed these medium-dry pigments into a waxy consistency with a drop of oil medium no. 1 and scrubbed them with old, worn round brushes over the cross-grained, colored ground. In this way, I let the "atmosphere" of the ground peek through, allowing the colors to breathe and creating a feeling of light from behind.

After the painting had dried for two days, I mixed a new batch of slightly thicker pigment with two drops of oil medium no. 1 and applied it in the semi-transparent shadow areas. Again, I scrubbed with a rough, round brush held flat to let the light through from the previous layer.

Finally, I mixed my color with Permalba white and used oil medium no. 4 for the prominent foreground lily. Both the light-struck color and the rich consistency of the paint bring this flower forward, so it almost pops out of the picture plane.

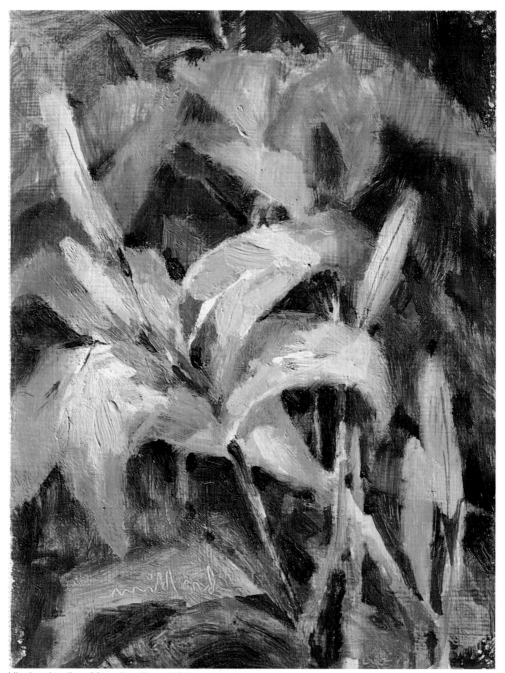

Lily Jungle, oil on Masonite, 9" × 6" (23 × 15 cm)

Building Solid Objects

This painting began in much the same way as the first painting I discussed (*Pumpkin and Pigeon Peas*, page 24). But here I went further, gradually adding small amounts of paint to selected areas to define the objects three-dimensionally. As these layers built on top of each other, they lent both a physical and a visual solidity to the objects.

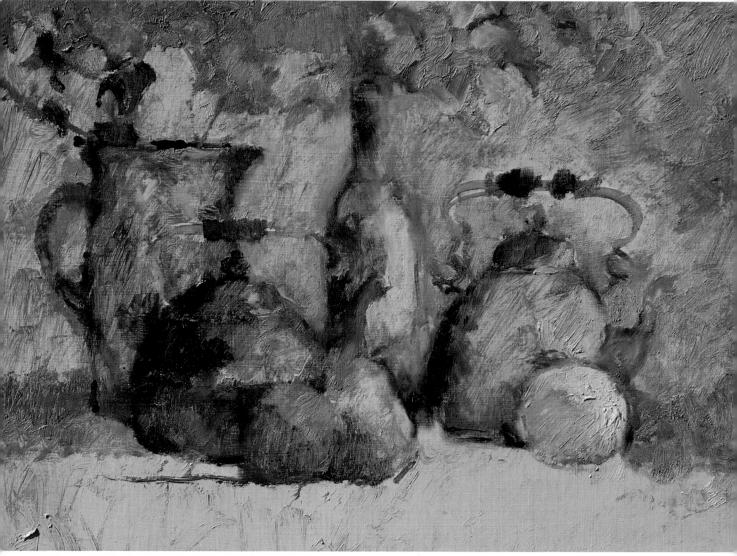

Kettles and Fruit, oil on Masonite, 20" × 24" (51 × 61 cm)

For this painting, I chose a Masonite panel that had been sanded with a fine emery cloth and coated with Liquitex gesso in a cross-grained pattern to simulate a finely woven linen. I then used a wash of cobalt blue and turpentine mixture no. 1 to draw the objects. Some of this original, very thin layer of paint can still be seen in the final painting. Next, I added some Blockx burnt sienna, kept quite clear and thin, to provide a brilliant complement to the blue. Again, some of this layer carries through to the final painting.

Then I turned to some deeper ultramarine blue accents, which began to set up atmospheric vibrations. I wanted to move into segments of thicker impasto, but I didn't want to overpower these subtle rhythms. Gradually, I increased the solidity of the paint, working in layers—as you can see in the kettles, flowers, and fruit. Although the paint handling may appear rough, there is a careful balance of thin against thick throughout, fostering the illusion of three-dimensionality.

Here you can see some of the vibrations set up by my initial washes of cobalt blue and burnt sienna.

A few touches of thicker paint help to define and accent the form of the flowers.

The thickest paint is reserved for the most intense highlight. Notice how your eyes are drawn to this point in the painting as a whole and then move circularly around the rest of the composition.

Modeling the Form

To capture the forms of the curved objects—the straw hat, the earthen bowl, and the water pitcher—I accentuated their rims with raised, thick paint. These impasto areas become even more emphatic in contrast to the more thinly painted angular shapes. In addition to structuring the form, the heavily pigmented strokes catch the light, adding to the rich, luminous quality of the whole.

The Straw Hat,
oil on 140-lb cold-pressed watercolor paper,
11″ × 18″ (28 × 46 cm)

To get the semi-gloss finish I wanted, I sealed the surface of my 300-lb handmade paper with a nonglossy Liquitex gesso. I used three coats on the front *and* the back to seal the surface completely. After doing an initial color lay-in with turpentine mixture no. 1, I added a small amount of oil medium no. 1 to my palette colors. By adding just a touch to my shadow color mixtures, I kept these from going matte, or flat.

For my white, I used Permalba, which I had laid out on brown paper for 15 minutes to soak up the excess oil. Too much oil impedes the ability of the raised impasto to hold its form.

If you continually experiment as you paint, you'll soon get a feeling for the chemistry of matte versus semi-gloss versus high-gloss finishes. I like to choose a finish that best expresses what I see in the subject.

4.

CREATING LUMINOUS EFFECTS

There are many different ways to create a luminous glow in your paintings. Two obvious methods are to use thick impasto to catch the light and to add oil medium to your pigments. A more surprising idea may be to remove the excess linseed oil from your pigments and then use the resulting matte finish as a foil for light-catching impasto. Several other ideas are explored in this chapter, including the use of overlapping strokes of broken color to set up luminous vibrations.

Capturing the Sparkle of Light

The sparkling light on this brightly polished silver pitcher prompted me to combine two whites—one buttery, the other relatively dry. The resulting mixture helped me to get the beads of light to sit up, thick and brilliant, without collapsing. Notice how here and there I used bits of impasto, shoveled up from my palette with the tip of my brush, to catch the light and add excitement. Small touches like this make the feeling of light believable to the viewer—as if he or she could reach out and touch it.

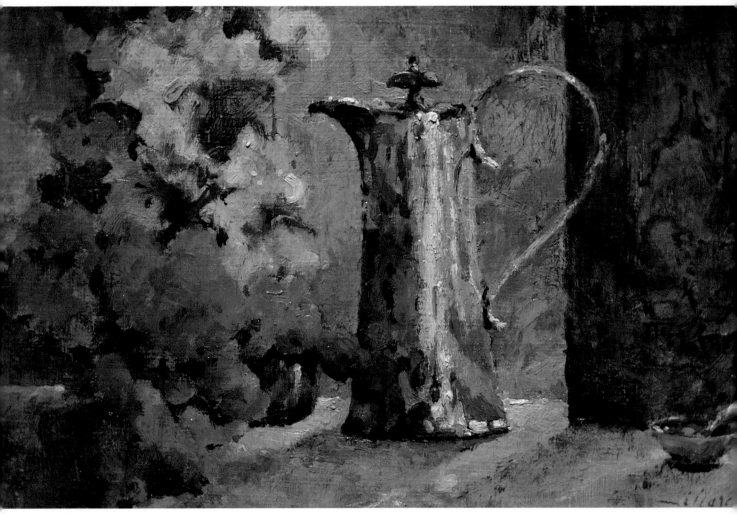

Silver Pitcher, oil on Masonite, 9" × 12" (23 × 30 cm)

To make my white, I first laid out a 3-inch (8-cm) strip of buttery Permalba white on a brown-paper supermarket bag and left it to dry for 15 minutes, getting rid of the excess oil. Then I transferred it to my palette, where I had already laid out a 2-inch (5-cm) strip of dryish Shiva underpainting white. After adding a few drops of turpentine mixture no. 2, I whipped the batch up, using 100 strokes of my 2¾-inch (7-cm) Winsor & Newton palette knife. I used this mixture with all my colors. As the painting progressed, I also added oil medium no. 5 to stiffen and hold the beads of paint.

This painting was not done *alla prima*; instead, I built up the thicknesses of paint gradually, over several days. It seemed as if I were literally building up the light forms as they came out of the background toward the viewer. The direction of my brushwork was important. Notice how the varied strokes of different thicknesses catch and hold the light with different intensities.

Actually, to create the feeling I wanted, I invented the sunlight in this scene. I also made up the Oriental screen on the right, behind the jewel-like salt cellar, for a stronger chiaroscuro. Remember, the subject is whatever *you* want it to be.

Adding Oil Medium Selectively

The radiance of an early morning in the Loire Valley can be a challenge to capture. Here there was a slightly hazy, orangish quality to the light as figures began to appear on their way to school or to the bakery for the morning bread. I decided to pep up certain areas, where the sunlight was striking, by mixing small amounts of oil medium into my colors. These luminous segments contrast with the color of the shadow areas, which have a flat, matte finish. The roofs, however, are an exception. I wanted the unusual quality of this dark pattern to supersede everything else.

Savonierres, France, oil on museum board, 9½" × 13" (24 × 33 cm)

After sealing a piece of museum board with shellac (see page 16), I sketched the scene with a pale, thin cadmium orange and scrubbed in the base color of red earth with Wharton no. 3 and no. 6 long-bristle brushes. I let this dry for a half-hour and then went over the basic shapes of the roofs with a rich mixture of ultramarine blue and alizarin crimson thinned a bit with turpentine mixture no. 2, outlining and heavily filling in the darks. Next, I worked on the thin, cool cobalt blue shadow areas of the house on the left, then added a warm, thin mixture of Naples yellow, terra rosa, and raw umber behind the two children and yellow ochre on the sidewalk in front.

For the heavier impasto areas on the sun-touched houses, two major figures, garden patch, tree, and sky, I used oil medium no. 4 in my color mixtures to add a luminous quality. Notice, however, that there are also some thick, rich darks in the roofs. (Darks don't always have to be thin.) All application of heavy, rich impasto is above the earth, giving the feeling that these objects are "reaching up into the sun," and thus creating this luminous quality.

The pinkish earth color in the sky is actually painted on; it is not the ground color showing through. Notice how this color mixture is repeated, but thinned, for the shadow area of the house with the pink roof. Color echoes like these help unify a painting.

Using Oil Medium Throughout

By adding oil medium no. 4 to all these color mixtures, I was able to give the whole painting a luminous, sunlit effect. The strawberries sparkle in imagined sunshine as they spill onto the table, and the gleam of the green plastic container provides an appropriate complementary note. The handling of the tablecloth also contributes to the luminous quality. It was first painted pink and then overpainted with juicy, translucent whites, so it has a see-through look. There are actually many subtle added touches of pink and off-white, which suggest the flicker of light on a white surface.

Roya's Strawberries, oil on Masonite, 9" × 12" (23 × 30 cm)

For this painting I used a panel primed with flake white in a fine cross-grained texture. First, I rubbed in the deep pink ground color with a piece of towel and let this dry for an hour. Next, I sketched in the basic motif using a Wharton no. 2 brush and Winsor & Newton permanent green, grayed with a touch of raw umber.

Although the actual setup was a sunless spot on my kitchen counter, I imagined the fresh strawberries in summer sunshine. To introduce some sparkle, I added two drops of stand oil to a tablespoon of oil medium no. 3 (half turpentine and half stand oil) and used this medium throughout. To give a sense of the berries spilling out of the shade and rolling into sunlight, I varied the kind and quantity of red, working with Bellini rose madder deep, Winsor & Newton cadmium red deep, Liquitex acra red, Winsor & Newton permanent rose, Winsor & Newton cobalt violet, and a touch of Grumbacher cadmium orange. For the shadows in the basket and at top left, I used Utrecht manganese violet and Winsor & Newton burnt umber. It was important not to add too much white or these colors would have lost their luminosity.

When I painted the tablecloth, I allowed some of the ground color to show through at the edge of the table. I also added some translucent touches of a mixture of cobalt blue, raw umber, and white to increase the shadow effect. For the sunlit areas, I built up layers of pink and white strokes, adding an extra drop of stand oil to increase the luminosity of the paint and using spirited brushwork throughout this area of the painting.

Removing Oil from Your Colors

It was near the end of the day when these trawlermen came in for repairs, and there was an odd glow to the light that I wanted to capture. To do so, I used very dry pigment for most of my painting, giving it a flat, matte finish. At the end, I added a few accents of thick impasto, mixed with medium so they would catch the light and glow. It is really the contrast between these two areas that gives this painting its luminous feeling.

Trawlermen, oil on Masonite, 6½" × 8" (17 × 20 cm)

For this painting I chose a Masonite panel that had been sanded with fine emery paper and given five coats of thinned Sani-flat (alkyd) white paint. I then began to experiment with two whites. First I squeezed a 2½-inch (6-cm) ribbon of Shiva underpainting white onto the center of my palette. Then I squeezed a 1½-inch (4-cm) ribbon of Winsor & Newton flake white no. 1 onto a porous paper plate, flattened it with a palette knife, and left it for 20 minutes so the oil would be soaked up. Then I mashed the two whites together, using turpentine mixture no. 1. When I first whipped the whites into a single mass, they seemed to curdle—but I kept on whipping for the full 100 strokes. Soon I was working with a creamy mixture. As I continued to mash the whites, the turpentine evaporated, leaving a stiff, dry mound of paint. I mixed this very dry white with my other colors, which had also been sitting on this paper plate to get rid of any excess oil.

Only when this painting was about 90 percent complete did I begin to add the highlights in thicker impasto. Just these few bits of raised pigment are enough to catch the light and give the painting a soft, velvety glow. It wouldn't have worked if all the paint were the same thickness.

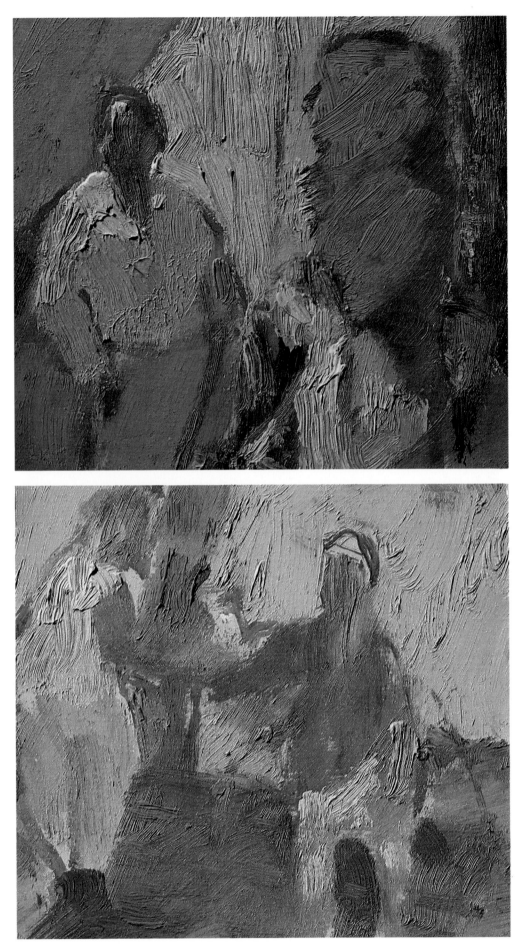

Scumbling on a Porous Surface

For this still life, I set up a single mass of overlapping objects, paying careful attention to the way the objects lead the eye toward the wine bottles. Although there is some buildup of paint, I kept the surface fairly even, without thick accents, so as not to distract from the mass as a whole. To add luminous vibrations, I scumbled rather dry colors over the porous surface. The result is a broken texture of color similar to the effect one sometimes gets with pastels.

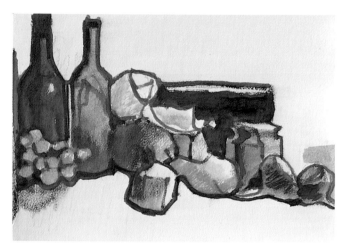

This rough underpainting gives the basic value structure.

For this painting I chose Arches 300-lb cold-pressed watercolor paper and sealed it with a shellac preparation (see page 16). Before beginning to paint, I put out my oil paints on a paper plate, which soaked up some of the excess linseed oil. My aim was to get a pastel-like quality with the colors so dry that I could scumble one color over another without mixing in or lifting off the previous color. My whites—Shiva underpainting white and Winsor & Newton foundation white—were also squeezed onto cardboard to remove the excess oil. All the colors sat for 20 minutes before I transferred them to my regular wood palette and whipped the whites in

the center (see page 18).

Next I did a rough underpainting in blue, outlining the shapes with relatively dark lines and indicating the main lights and darks. Then I scumbled in the background, using dry pinks and lavenders and ochres, all mixed with white, to create very pale hues. I continued to add colors, scumbling them on in layers so the previous color showed through—much as in open-stroke pastel work. The only medium I used was turpentine mixture no. 1. Then, when the painting was finished, I framed it under glass—just as Vuillard did with his fragile, dry colors, to protect them against airborne pollution and dirt.

Blue Book Arrangement,
oil on 300-lb cold-
pressed watercolor paper,
9" × 12" (23 × 30 cm)

This detail clearly shows the matte, pastel-like finish.

Blurring the Edges

In *Cheesecake*, I again used a relatively dry impasto, but here I experimented with a slightly different technique to unify the painting and give it a luminous glow. Only after I had completed the painting with built-up layers of color did I add a luminous touch—by softening the sharp impasto edges with my thumb after the pigment was nearly dry. The effect is a subtle blur—as if you were squinting at the still life, with everything just a bit out of focus. It's an idea I got from looking at one of Monet's paintings in his Rouen Cathedral series. Why not give it a try yourself?

Cheesecake, oil on Masonite, 9″ × 12″ (23 × 30 cm)

I began by putting all my colors and my whites on a porous paper plate, letting it soak up the excess oil for 10 minutes. Using Shiva underpainting white and Winsor & Newton flake white no. 1, I added just enough turpentine mixture no. 1 to be able to blend and whip my whites. Then I let the whites sit for 20 minutes as the turpentine evaporated. As I painted, I added very small amounts of turpentine medium to all my mixed colors and let them rest 15 or 20 minutes to dry out.

If you look at the details, you can see the different ways I handled the edges, creating both a sense of depth and a luminous glow. The dark edges of the rose and apple, for example, are relatively sharp, while the green bottle has softer edges, formed by smudging the paint with my thumb after the paint had set for 15 minutes. The thumbed edges give the bottle an out-of-focus quality. Also—given the touches of green in the background—from a distance, the bottle seems to flicker in and out of its surroundings.

The two wine goblets also have thumbed edges, providing a luminous glow. In comparison, the edges of the cheesecake seem crisp, but here the similar color behind the cheesecake causes a visual blur, so the image seems to move in and out of the background. There's also an in-and-out movement between the aggressive background and indecisive candle edges.

Compare the relatively sharp, dark edges of the rose and apple with the softer edges of the green bottle, where I smudged the paint with my thumb.

In the two wine goblets you can see how thumbed edges contribute to the luminous effect.

Both the cheesecake and the candles seem to move in and out of the background, creating a subtle luminosity.

Overlapping Fingers of Color

As I sat in line at the customs booth, waiting to cross from Italy into France, this farmhouse was lifted out of the mountain mists in a brief wash of sunlight. I only had time for a rapid pencil sketch, so the rest had to come from memory. What stood out for me was the way the grape stakes "knit" the two vineyard patches together and the way one end of the farmhouse glinted in the light. I thought then of how I'd use overlapping fingers of color to capture this luminous effect. If you single out how impasto might catch the eye, this will help your "memory painting."

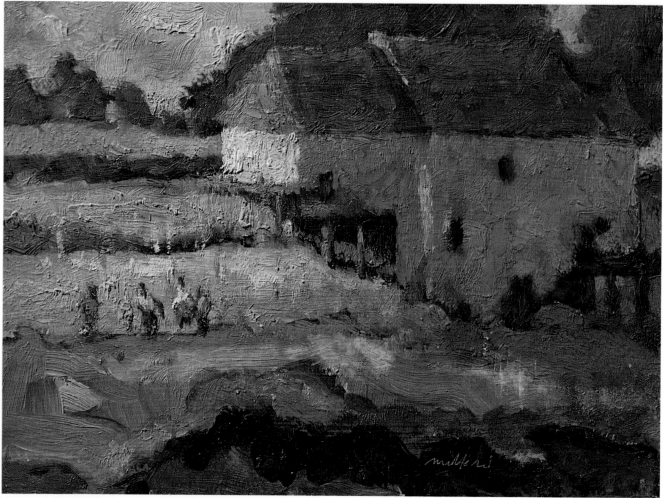

Vineyard in Ventimiglia, Italy, oil on Masonite, 5" × 7" (13 × 18 cm)

There are similarities between the luminosity in this painting and that in *Cheesecake* (page 54). Both have sharp-edged, contrasting darks in the foreground, as well as "uncertain" or broken edges of impasto. But there were differences in the way the luminous effects were achieved. Here the color was scumbled over previously painted segments in thin dry strokes so as to diffuse the edges. You can see this not only in the farmhouse, but also in the various divisions on the left: the clouds, trees, meadow, shadow, and two vineyards.

Look, for example, at the trees. They were initially painted green. Then I added a thin layer of lavender; then some blue was scumbled in. The stakes connecting the two vineyards were also built in layers of broken color—flecks of yellow over terra rosa over green. On the figures, I added thicker flecks of paint here and there, letting them "grow" out of the more thinly painted vineyard until they felt right. Now look closely at the shadow side of the farmhouse, which is built up with many, many touches of impasto. The one brilliant spot in the painting—the sunny end of the building—is made up of thick, off-white impasto, like the frosting on the cheesecake. My whites were Permalba and Shiva underpainting whites.

In addition, I used oil medium no. 4 to get the semi-gloss finish.

This painting, by the way, was one of five oils of various sizes I had going at the same time in my studio. While one of the larger paintings was setting up, I'd be pecking away, adding bits of colored impasto to this small oil. I like to work back and forth between paintings in this way, letting each one grow at its own pace until it's done.

Applying Impasto Highlights

To interpret this hot, dry Venetian village in the late afternoon sun, I decided to use a rather dry impasto on shellacked paper. The low shadows had pulled the darks together, adding—by contrast—to the sparkle of the whites and the flesh of the woman. To capture this effect, I applied a few thick white accents on the laundry, as well as the window and the door frame. You can feel the way these areas catch the late-afternoon light.

Because I wanted a flat, but not dull, matte finish, I chose a 300-lb, 100 percent rag handmade paper (the back of a rejected watercolor) and sealed it with shellac. I then squeezed Permalba and Shiva underpainting white in 3-inch (8-cm) and 1½-inch (4-cm) strips, respectively, in the center of my wood palette and whipped them with turpentine mixture no. 2 into the consistency of sour cream. I then let this whipped white set for 18 minutes, allowing the turpentine to evaporate.

For the first lay-in, I mixed my colors with this white plus a little of the turpentine mixture and scrubbed the paint on with a round bristle brush, holding the brush in a flat position. The second layer was applied rather richly only in the areas where the sun struck. Again, I scrubbed rather than rolled on the paint. At this point I literally built up the woman's nose—as well as the white shirt—with paint. I also added the dark line that defines the corner of the building, rapidly pushing it upward from the shadow in the window with a very dry brush.

Next, I picked up touches of white in varying thicknesses and sculptured the sunlit window frames in deft strokes using old, worn-out round brushes. A lot of

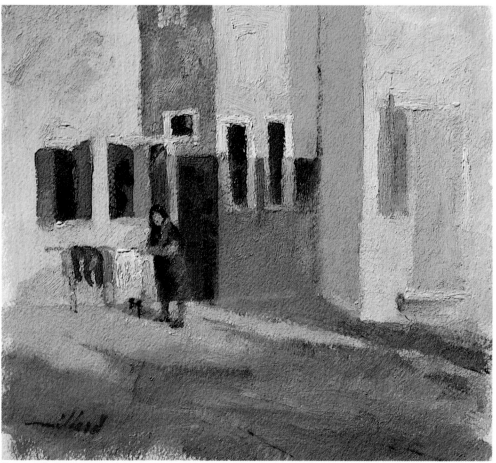

Burano Washerwoman, oil on 300-lb watercolor paper, 9″ × 10″ (23 × 25 cm)

my decisions here had to do with what felt right. I definitely didn't want to model this centuries-old building with crisply calculated, sharply accented brushstrokes.

As you look around this painting, notice the different textures of paint and the way the colors play against each other. The spot of orange near the woman's face provides an important contrast. The different colors of her legs—one pale Venetian red, the other the blue of her dress with a touch of red—help to define the flow of light. Also, notice the tiny drybrushed window near the top. It makes the thick impasto windows below all the more emphatic.

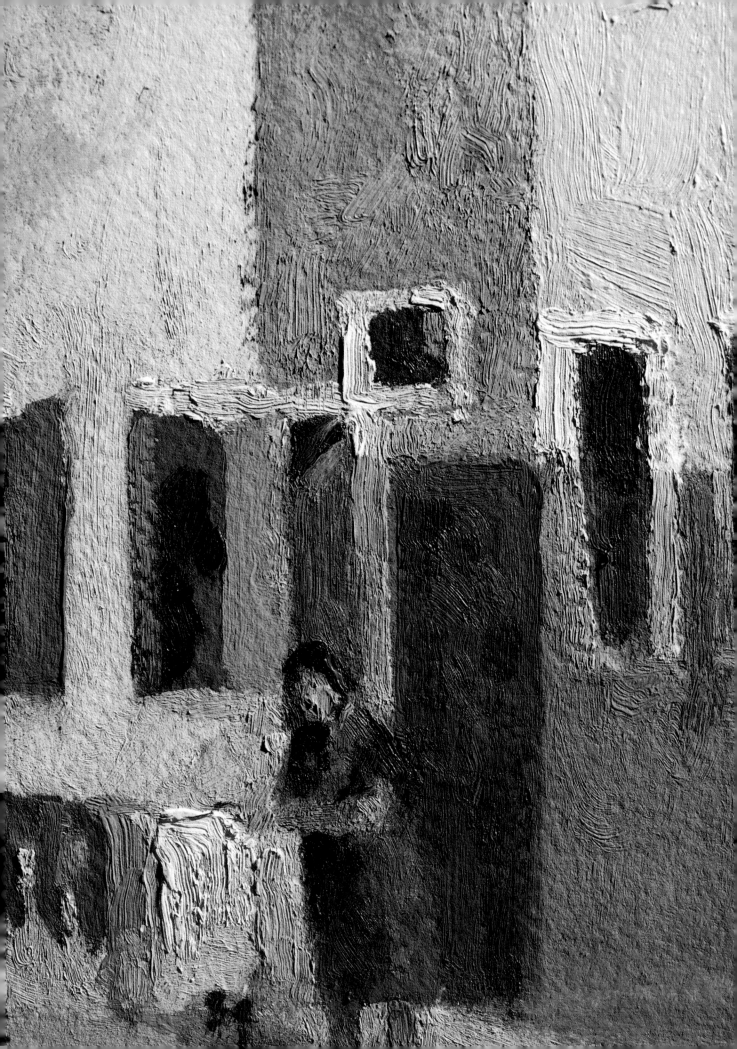

Using Thick Darks

As a rule of thumb, it's usually said that you should keep the shadows thin and build up the lights. But you don't always have to follow the rules. In *Avery's Birches*, for example, I used relatively thick paint in some of the dark, forested areas. These darks are important as negative shapes in the design of the painting, and the thicker paint helps to set up a lively tension with the lighter shapes around them.

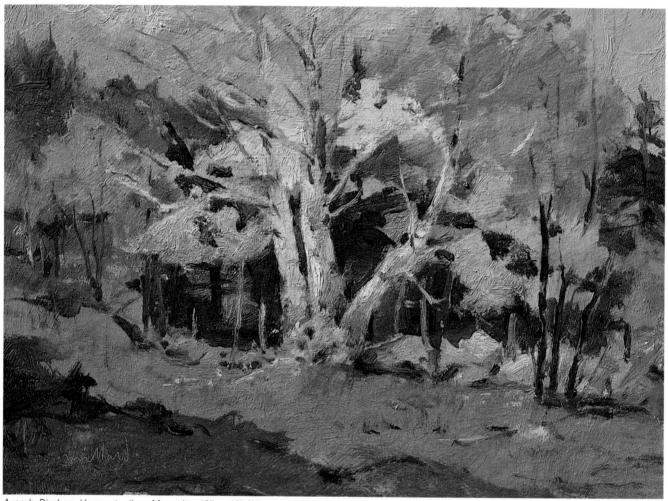

Avery's Birches, Vermont, oil on Masonite, 12″ × 16″ (30 × 41 cm)

For this painting, I used a warm pink earth toned ground. After drawing the scene with red paint and a no. 2 Wharton brush, I began to build up thin patches of color in the sky, field, and woods. With the next layer, I added a few fallen leaves in the field and more color in the woods. Then I continued to work on the leaves and tree trunks, concentrating my attention and the buildup of paint in the central area. At the end, I quickly put in a few highlights on the birch trunks and in the sky.

To get the rich surface finish I wanted, I used oil medium no. 5 with my paints. This glistening effect contributes to the sense of radiance in the center. Notice the many areas where the original pinkish ground shows through, infusing even the dark areas with a feeling of light and helping to unify the painting as a whole.

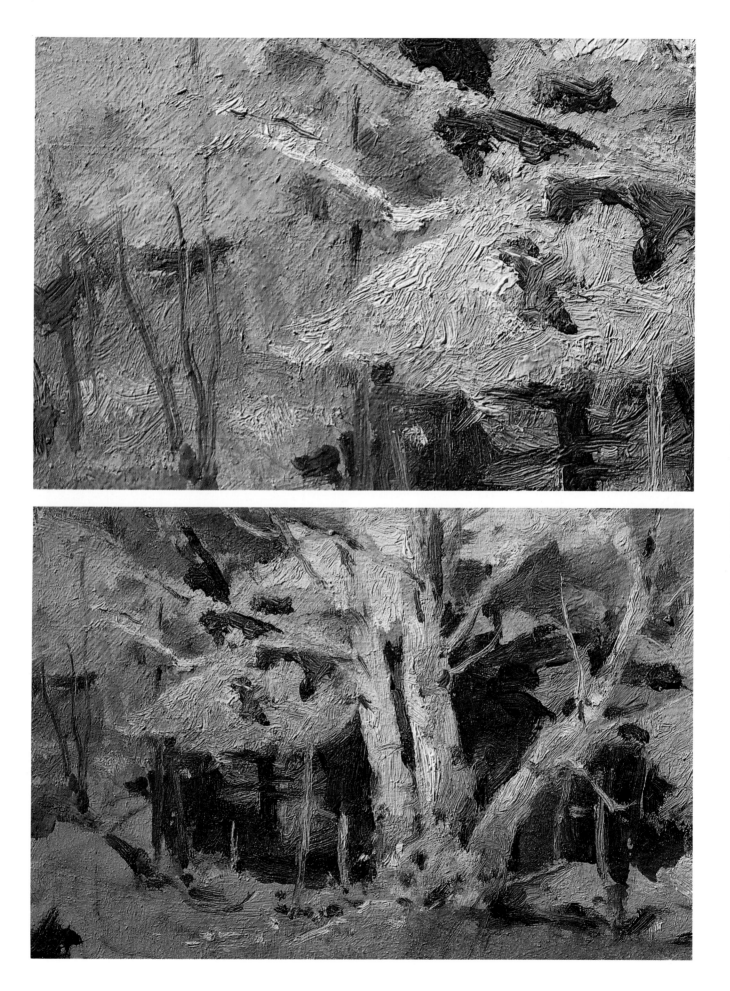

5.

USING THE GROUND TONE

The ground color of your support can play an important role in the final painting—it doesn't have to be covered up entirely. Try thinking of it as the initial, underlying layer of paint. Experiment with rubbing either a warm or a cool color into a primed panel or canvas surface. As you can see in the paintings in this chapter, a background color can suggest weather, time, or mood . . . contributing to the viewer's emotional experience.

Leaving the Ground Exposed

Even if you don't give your ground a special tone, you may want to leave it exposed. In this portrait, you can clearly see the original ground, not only at the bottom, but also in the nose and cheek area. There are places where it shows through the scumbled red background, creating an atmospheric effect. The old masters often left the ground exposed like this. To me, it adds a special humanness, an unexpected humble touch, to the work.

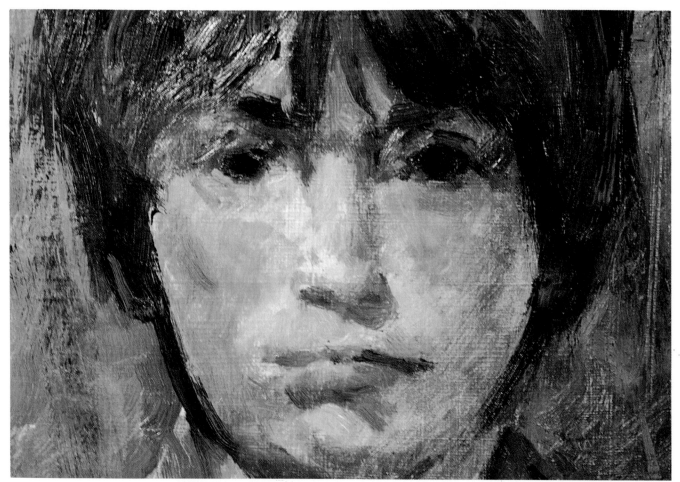

The three-dimensional feeling of this head comes in part from the layering of color. Although there is no heavy impasto, there are definite differences in thickness and opacity, which create a back-and-forth spatial effect. Notice how the brushstrokes contribute to the definition of form and also provide an important contrast to the lightly scumbled areas.

Portrait of Preston, oil on Masonite, 24" × 20" (61 × 51 cm)

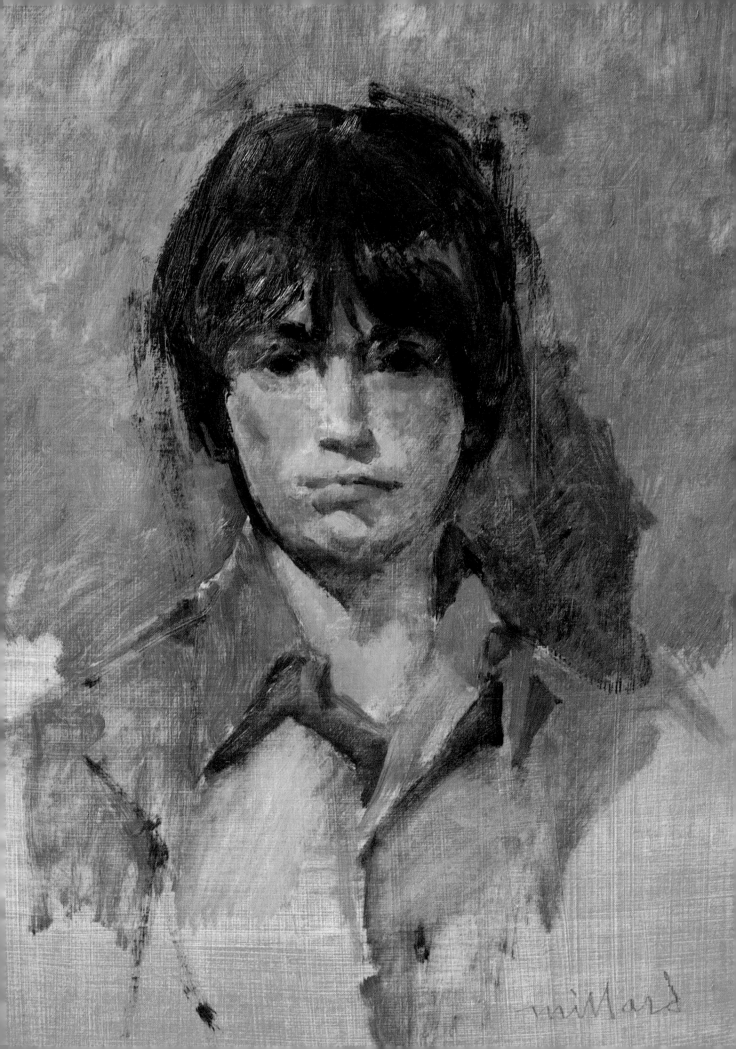

Building on a Toned Ground

This step-by-step analysis gives a closeup look at how I build a painting in layers on top of a colored ground—in this case, Venetian red rubbed over a round-ridged texture. I've deliberately focused my camera on details so you can see the texture of the paint more clearly. Overall, the layering process creates a rich atmosphere, with one color breathing through another, and helps to give an individual character to this particular motif.

After doing a series of small carbon-pencil sketches and a small watercolor, I laid in the scene with a mixture of yellow ochre and cadmium yellow medium with touches of green earth on a Venetian red ground.

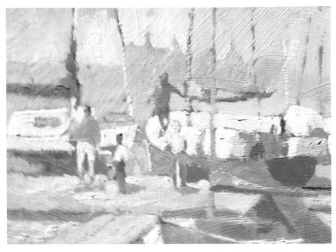

In this look at the center area, you can see the initial block-in of color. Notice how the red ground color comes through, especially in the masts.

The vigorous brushwork in this detail of the sky suggests the exhilaration with which I attacked this painting. Some of the texture, however, comes from the brushwork of the ground reading through.

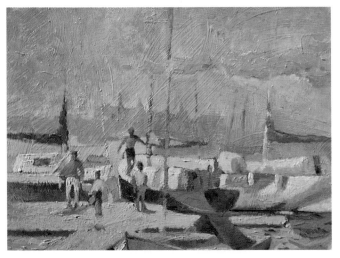

Gradually the paint builds. The central figures become more clearly defined; the city skyline becomes a darker gray, with thicker impasto; and the pink cloud takes on importance with the addition of richer paint.

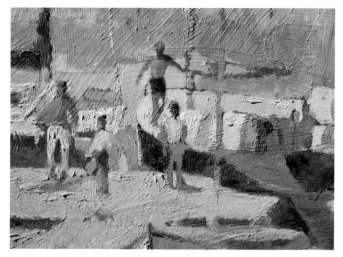

Notice in this detail how the different levels of paint add to the feeling of space. The red ground also sets up vibrations with the other colors.

Now these figures in the cockpit receive thin, but not anemic, touches of paint. They are onlookers, not to be confused with the four major characters (seen clearly in the last detail).

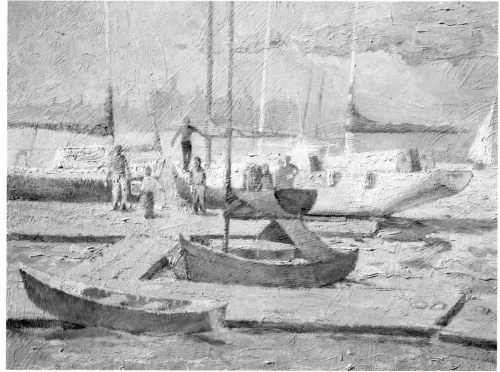

Gloucester Weekenders,
oil on Masonite,
30″ × 36″ (76 × 91 cm)

In this slightly cropped view of the final painting, you can still see hints of the original ground, especially in the background areas. Notice how the buildup of white paint on the boats creates a lustrous aura around the figures, even the onlookers. Also notice how much the vertical accents and changing colors of the masts add to the structure of the whole.

This seemingly innocuous rowboat in the foreground is really a scene-stealer, making the image more than just a group of people gaping at a camera. You can clearly see the red ground breathing through the other colors on the side. It is this kind of layering that can make a painting live in the viewer's eyes.

Creating a Warm Inner Glow

When I saw this group of people preparing their evening meal on an open beach fire at sundown, I wondered how I might catch the beauty of the scene. Most of the heads were lost in the shadow of the thatched roof, while the legs were more or less absorbed into one dark tone. What was left was the glow of light, creating interesting shapes between the figures. To capture this effect, I used a red earth ground and let it show through much of the painting, as if I had put a red gelatin over the lights on stage.

To produce a warm inner glow, I chose terra rosa and cadmium red for the ground color. After mixing in turpentine mixture no. 1, I let the solution evaporate and dry out for 15 minutes. Then I rubbed the dryish color with a rag over a fine, cross-grained surface of Liquitex gesso on Masonite.

Everything else—the figures, tree trunks, leaves, and smoke—was painted in layers on top of the red earth color. Each step was carefully planned to ensure lively negative shapes in the areas where the ground shows through between the figures. To add some life to my darks, I used a mixture of Winsor & Newton ultramarine blue and Grumbacher alizarin crimson for my black and Rembrandt terre verte brulée for a rather translucent brown. I added a touch of Rembrandt Chinese vermilion to give a kick to the reds on the surfboard overhead and the back of the central figure's shirt.

As I applied touches of pigment, I used restraint so as not to overpower the glow. At times I painted with my fingers—smudging the color off the shoulder of the right figure, for example, so he would turn into the space of the background. Notice how I used the off-whites of the smoke and trees as selected accents to push the reddish glow farther back in space. There's a sense of penetrating back into space to reach the ground at the same time that there's a sense of the warm color pushing forward, moving the whole scene close to the viewer.

Beach Supper, oil on Masonite, 9" × 12" (23 × 30 cm)

Enhancing Somber Grays

It was a raw, gray day in November, when the last leaves were barely hanging onto the maple tree. To add impact to the soft, somber grays, I decided to use a warm pinkish ground and to let it show through in enticing patches here and there. Notice, in particular, how this ground pushes the cool gray clouds and trees forward, giving them dimension. You might try a similar undercolor device to enliven a dull painting.

First I sanded a panel with both horizontal and vertical strokes to give it a cross-grained texture. After dusting off the panel, I applied a first coat of Benjamin Moore's Sani-flat white paint, using vertical strokes and a Grumbacher no. 16 white bristle brush. Two days later, I applied a second coat of this alkyd paint, working in a horizontal direction. I find the Sani-flat paint helps to dry my oils a little.

Next I mixed a thin pinkish color all over the panel with a piece of fine cloth. To give this ground color some "grab" on the alkyd surface, I put half a teaspoon of turpentine mixture no. 2 in my palette cup and added a drop or two of stand oil.

After letting the ground color dry for three days, I did the rest of the painting on the site in an hour. My palette consisted of yellow ochre, cadmium orange, terra rosa, rose madder extra deep, cobalt blue, raw umber, Naples yellow, burnt umber, Utrecht titanium white, and zinc white (set out on paper for five minutes to dry out any excess linseed oil). I put about half a teaspoon of turpentine mixture no. 2 in one cup on my palette and half a teaspoon of oil medium no. 2 in the other.

My first step was to sketch in the main part of the maple tree, for scale and position. After painting the side of the barn up to the tree and the roof, I scrubbed the mountain up to the roof. Next I turned to the dark end of the barn, using plenty of medium. After about 15 minutes I scratched

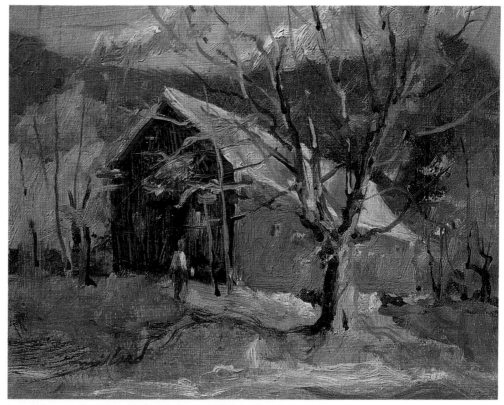

Last Leaves to Go, oil on Masonite, 8" × 10" (20 × 25 cm)

this area vertically with my left fingernail (cleaning my finger immediately afterward). I then scrubbed in the foreground and sides of the painting, using varying thicknesses of paint. By now the paint was beginning to set up on the palette, in the cold, so it was time to superimpose the tree branches, the figure, and the clouds in thicker impasto over the earlier, thinner paint applications.

In the final painting notice how the pink undertone sets off the luscious grayed colors and at the same time unifies the whole. Also notice how the interplay between different degrees of impasto—thick and thin—adds a back-and-forth visual movement to the space.

6. SETTING UP ATMOSPHERIC EFFECTS

Creating a sense of atmosphere in a painting is not as difficult as it may seem at first—provided you are willing to experiment. By working in layers of paint, you can set up color and texture vibrations with a back-and-forth, in-and-out movement—suggesting the flow of air between things. Study the paintings in this chapter and the next to gain a better understanding of how specific colors and textures affect both atmosphere and mood. Then experiment on your own.

Creating Atmospheric Vibrations

If you look closely, you should be able to discern at least three distinct layers of impasto in this painting. As in my painting *Mums by the Window* (page 39), the different applications of impasto, with one layer peeking through another, set up a feeling of space between the objects . . . or atmosphere. Once again, you need only a minimum of impasto to take you over the border from a flat, two-dimensional look into the illusion of three dimensions.

Wood Bowl, Wine, and Pomegranate, oil on Masonite, 9″ × 12″ (23 × 30 cm)

For this painting I used a panel with two differently textured grains. The vertical strokes of gesso were applied with a relatively fine brush, while a coarser brush was used in the horizontal direction, lending emphasis to the horizontal.

My first step was to sketch in the motif with a no. 2 Wharton brush using raw umber thinned to a watery consistency with turpentine mixture no. 1. Since I wanted to emphasize the red of the wine and the pomegranate, I decided on a very thin, but opaque, layer of paint for the background: green-gray above, for the wall, and pink-white below, for the table. I rubbed these colors on with a rag, in a rough gesture. Then I rubbed the wine bottles and three fruits with the same light pink.

Next, with a beat-up old no. 6 round bristle brush, I roughly scrubbed a slightly heavier layer of paint over each area, giving it its "proper" color. Instead of the turpentine mixture, I used a small amount of oil medium no. 1.

After letting the pigments set for an hour, I applied a third layer of thicker color, scrubbing it on rapidly and vigorously with a no. 4 Wharton brush. As I scrubbed, I took care to leave plenty of "skip marks" or "misses" so the two earlier applications would peek through, creating a feeling of atmospheric vibrations between different layers of color.

Before adding the final highlights, I let the painting rest for an hour. I then placed a touch of the green-gray background color on the pomegranate, a bit of pale cerulean blue on the wine bottle, a spot of cadmium orange on the carrot, and a dot of pale manganese blue on the garlic. Finally, I swept a flick of flake white onto the orange with a beat-up no. 3 round. The separated hairs contributed to the unique quality of this lone white.

Suggesting Atmosphere Touch by Touch

This French landscape in early morning light is made up of many small dabs of paint . . . building, building, building, one spot at a time, into the whole. My aim was to capture the rosy glow of light without burying the delicate pink tones in heavy brushwork, to convey the sense of pink dawn peeking through dabs of soft cobalt green leaves and grass. As I added the different touches of paint, brushmark by brushmark, I could feel Monet and Vuillard watching.

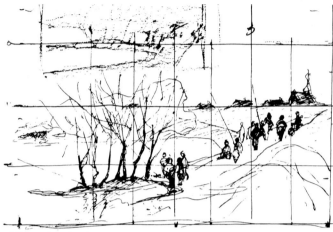

This quick sketch gave me the basic compositional information, and I used a grid to transfer it to my painting.

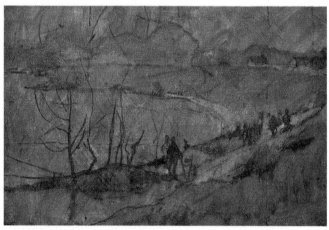

My first step was to rub a pink earth tone over the slightly textured canvas ground. After drawing the main elements in rose madder, I began laying in the main color areas.

The final painting is relatively thinly painted, with many small dabs of color. The original ground tone shows through in many places; this helps to imbue the scene with a warm light.

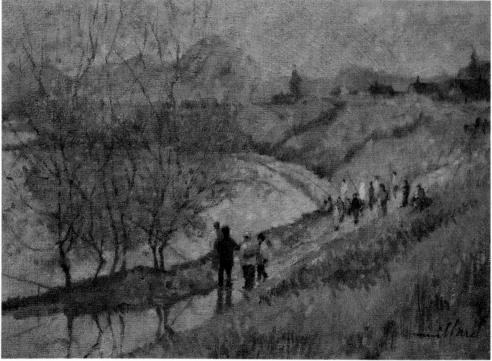

Fishing the Cher River, France, oil on linen, 12" × 18" (30 × 46 cm)

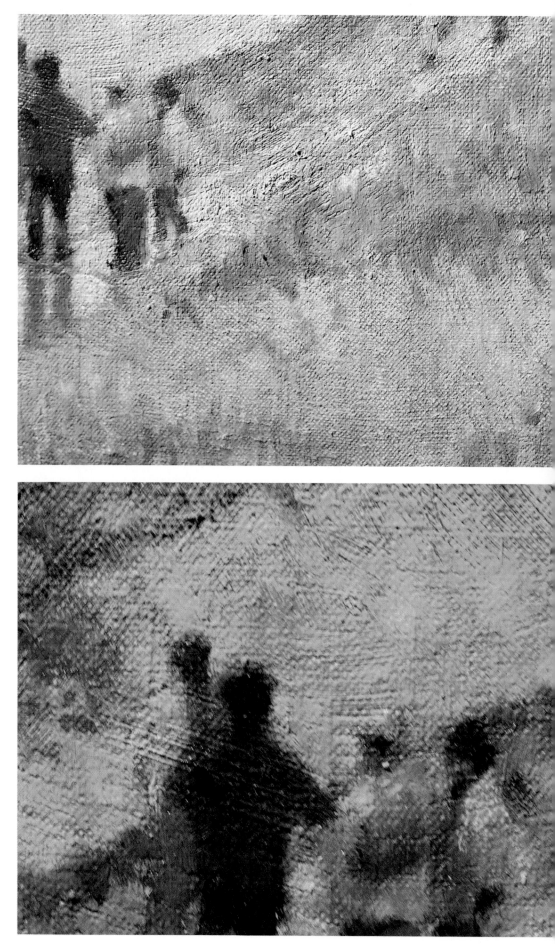

The warm orangish tone underneath sets up a vibration with the greens and purplish hues on top. Also, notice the dryness of the paint, which contributes to the quiet, hushed quality of the scene.

The handling of these figures is both simple and delicate. Tiny touches of color—such as the pink shirt, set off by the underlying red, and the yellow hat—enliven this area and make you want to look more closely.

Conveying the Atmosphere of a Bar

The interior of this Parisian bar presented a number of painting challenges. Although the figures were central to the composition, I was also intrigued by the bottles and the way they suddenly jutted out of the dusky back space. Similarly, in the foreground I was interested in showing how the used glasses gradually took form, growing out of the shadows. Then there was the problem of the two windows, with the light streaming in in equal amounts. How could I keep these windows from competing and splitting the focus? The solution lay in my handling of both the color and the thickness of the paint.

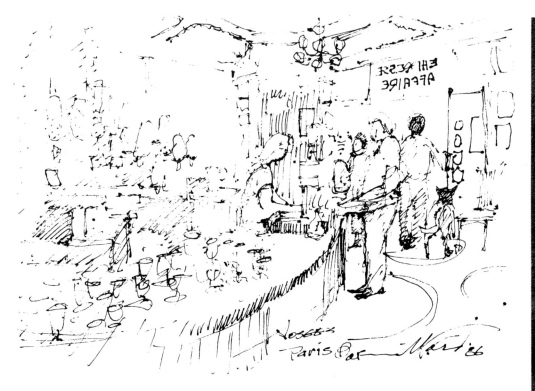

After doing this quick ink sketch during lunch, I decided to use the same pen to draw the scene on the white gesso surface of my canvas.

The many small touches of color help to convey the lively flicker of light in this interior. Dabs of thicker paint, such as the one on the barmaid's cap, highlight areas of importance, adding to the compositional pull toward the barmaid and her customer.

Compare the impasto treatment of these two windows: The left window is built up with many small touches of warm and relatively heavy impasto, making it the aggressor; the other window is cooler, with fewer dabs of paint, so it is less competitive.

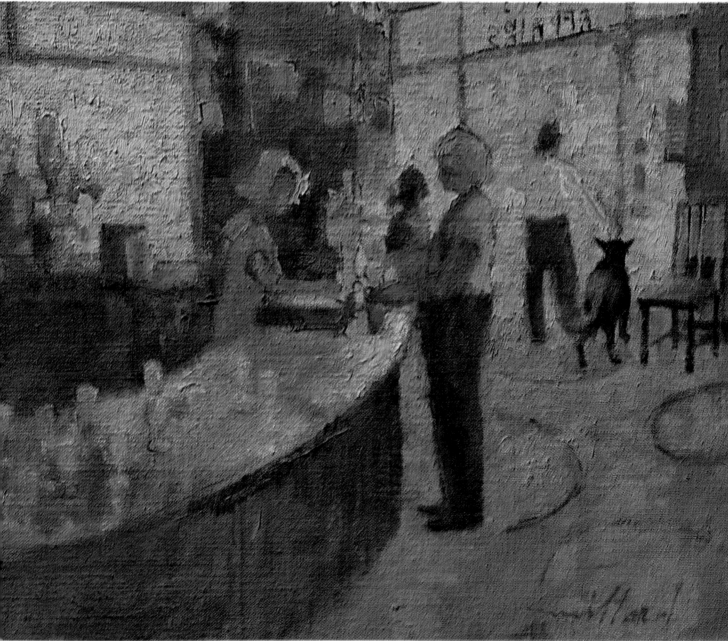

Vosges Bar, Paris, oil on linen, 12″ × 16″ (30 × 41 cm)

Removing Impasto for Atmosphere

So far we've been gradually building impasto, working from thin to thicker layers of paint. But sometimes it can be just as effective to reverse the process and remove some of the impasto. You can expose the weave of the canvas by rubbing with a rag. The light then strikes the canvas nubs, which poke up through the muted color. It is as if the atmosphere were sparkling from *inside* the painting.

I painted this still life in an hour and a half, then went away for 30 minutes for a sandwich. When I returned, the painting looked too dark—like an old Dutch painting. So I took a clean rag and began to scrub off some of the paint, allowing the canvas threads to show through. As I rubbed the color off these nubs, the painting began to breathe with light.

Much of the bottom half of the painting was rubbed off, as were parts of other areas. In reworking these areas, I returned the barest amount of color to the carpet and to the dark background near the orange peel and under the tabletop— just enough to enrich the zone of focus there. I also carefully added impasto to the orange, ceramic jar, and dark wineglass. I didn't rework these objects completely, but rather concentrated on building up the highlights with impasto. Actually, on the wineglass, it is the darks that are built up, leaving the rubbed, stained linen for subdued highlights.

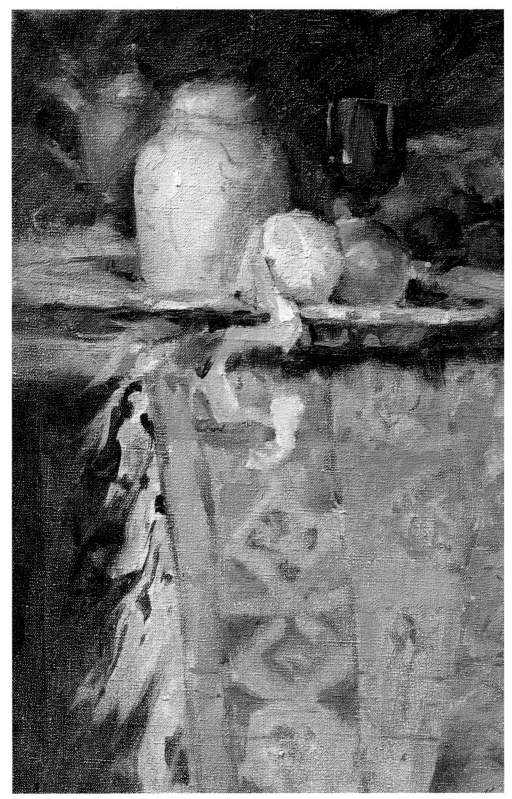

Still Life on a Carpet, oil on linen, 16" × 12" (41 × 30 cm)

On this wineglass the darks are generally thicker than the lights. Notice, in particular, how the nub of the canvas shows through the lights on the right.

The thickest paint is reserved for the focal point—the peeled orange.

Rubbing off the color in this area created a feeling of light breathing through. Imagine the closed-in feeling that might have occurred with thicker paint.

7.

EXPRESSING DIFFERENT MOODS

Almost every choice you make in a painting—composition, value, color, and texture—affects its expression. The more you paint, the more you'll learn about controlling these elements to get the impact you want. The paintings on the following pages show a range of possibilities—from the loud, energetic excitement of the still life on this page to the quiet poetry of a landscape at the end of the day.

Orchestrating Excitement

The rectangles of the paper bags presented such a strong contrast to all the rounded shapes in the rest of the still life that I was inspired to create a painting with a high excitement level. I decided on a range of thicknesses—from the exposed canvas and thin turpentine washes to areas of thick, crusty impasto. The brilliant color fits in with the rugged impasto feeling.

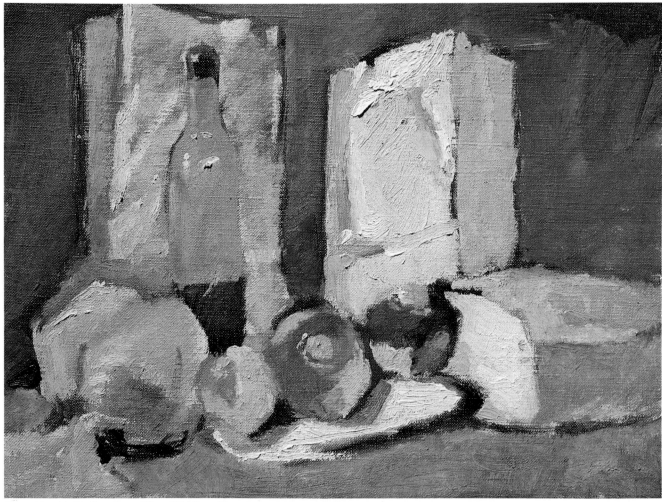

Paper Bag Motif, oil on linen, 9″ × 12″ (23 × 30 cm)

My first step was to apply rabbit-skin glue and two priming coats of Grumbacher flake white to my Utrecht J66 linen canvas. The advantage of this linen is that the horizontal nubs of thread will read through thinly pigmented areas, contributing to the excitement of the painting.

Next, I laid out all my colors, including the Grumbacher flake white, on a brown-paper bag for 25 minutes to soak up excess oil. Then, using turpentine mixture no. 2, I began with turpentine washes of color. Gradually, I built up the paint, working in thicker and thicker applications. As the excitement grew, I applied my colors directly on the canvas, instead of mixing them on my palette first. My strokes became more and more gestural, culminating in the enthusiastic thrusts of thick white impasto.

The strong color—Venetian red—in the background helps to key the excitement of this painting. The blue and black accents emphasize the drawing and add energy while helping to unify the disparate objects. But it is the thick, powerful strokes of white that really bring this painting to life. Without these areas, the painting would lose a lot of its vitality.

Finally, take a look at the design—particularly the use of positive and negative shapes. Turn the painting upside down to see what an active role the spaces between the objects play.

Creating a Tone Poem

This subject had such a strong silhouette that I thought I'd take liberties and experiment with mood, suggesting sunset or moonlight or perhaps just a poetic feeling. The texture that you see comes primarily from the hard-ridged ground. Essentially I worked with thin glazes of color, scumbling or dragging them over a warm terra rosa base. The underlying ridges made for some unevenness, contributing to the overall luminosity.

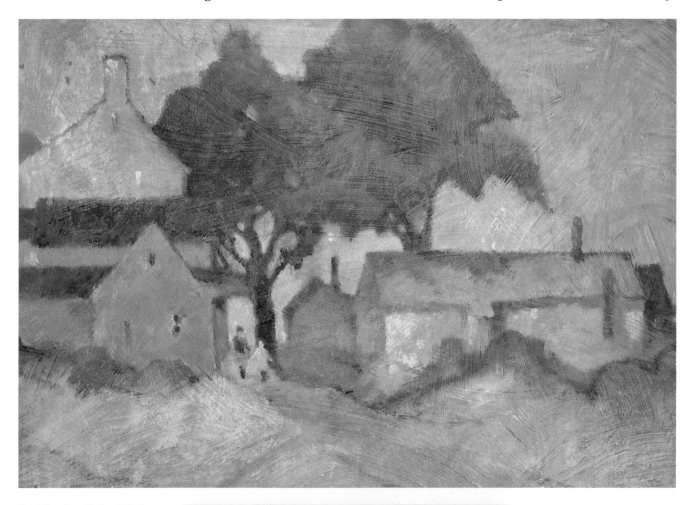

Initially, I applied a thin layer of color, using a staining method so the color would penetrate into the sharp ridges. For the second layer—done three days later—I scumbled slightly thicker color into, but mostly across, the raised ridges.

This detail shows the scene two days later, when I glazed a thin stain of ultramarine blue (with a touch of ivory black) over the trees to achieve a moonlit effect. The contrast, however, became too strong, and the negative shapes of light between the branches began to upstage the painting as a whole, so the sky had to be toned down to lessen the "pop" of light.

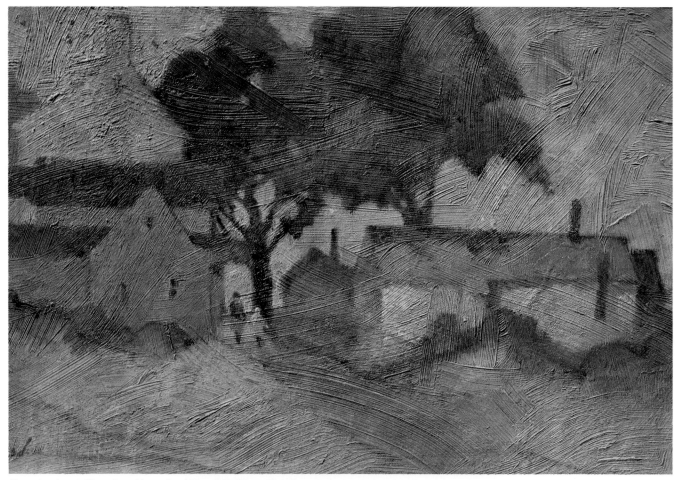

Kennebunkport Elm, oil on Masonite, 14″ × 24″ (36 × 61 cm)

My next step was to work with a yellow-orange mixture, quite dry, and touch it lightly across the foreground, introducing a warm, sunny quality. Then I proceeded to work warm glazes over the rest of the painting. At this point I added finishing touches of flake white . . . highlighting the girl's head, for example.

The impasto is heaviest in this area, filling in the initial ridges. I added a bit of grainy sand to the pigment to reinforce the idea of falling leaves.

Gesturing with the Paint

The colors and shapes in this still life excited me, and I wanted to convey this excitement with the paint. I deliberately chose a small panel to contrast the intimate size with the assertive handling of the paint. When you look at the details, you can clearly see the gestural quality of the brushwork. Although a lot of the paint is thick and juicy, there's also an important contrast between the impasto areas and the orange, where some of the paint has been removed. Sometimes it can be just as effective to take paint off as to put it on.

For the most part I followed this compositional sketch in my painting. The main thing I changed was the size of the bottles.

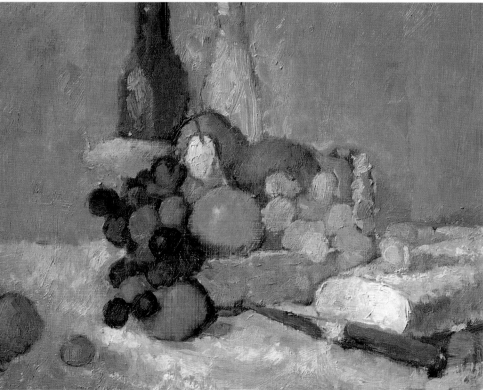

Notice the way I've aligned the dark grapes vertically to pick up on the power of the dark bottle. This dark column serves as an anchor for the rest of the painting, which is in a high key.

Nadine's Dark Grapes and Pear, oil on Masonite, 9" × 12" (23 × 30 cm)

As a contrast to the buildup of paint on the grapes and pear, I removed the impasto from the orange with my thumb, exposing the subtle grid pattern of the ground.

The end of the cut loaf and the highlight on the blade are especially built up, to repeat and support the contrast with the orange. Notice in the composition as a whole how the blade of the knife actually directs the eye to the orange.

Telling a Romantic Story

Initially I sketched these buildings because I liked the design of their shapes, but I wanted something more for my painting. I imagined a boy and a girl meeting in the foreground, with the mother looking on from above, unbeknownst to them. The cool morning light set the tone for this tender scene. I also took care to "quiet" my brushwork. Too vigorous an application of the paint would have destroyed the hushed quality I wanted.

In keeping with the mood I was after, I chose a fine, cross-grained, gessoed Masonite panel. My basic white was Winsor & Newton foundation white (with the excess oil removed), and my medium was oil medium no. 1 (with an extra drop of linseed oil added later, as the painting neared completion).

Notice how the layers of paint create a back-and-forth movement in and out of space. Look, for example, at the handling of the mother and child on the balcony. Although there are a few subtle touches of impasto to bring these figures forward, they also seem to sink into the shadow of the balcony doorway, as there are no light-catching edges of paint.

Now take a look at the quiet yellow sky, where the texture of the panel shows through. This area, which was painted first, helps to key the painting's mood and provides important breathing space. The lively *alla prima* brushwork of the dark palm then immediately attracts attention, directing the eye to the similarly colored doorway with the mother and child below. On the other side, the green palm leads down to the brilliant impasto highlights on the roof, which in turn lead to the boy and girl. The impasto here intensifies the feeling of light at the same time it guides the eye.

I had already nearly completed the two buildings before I tackled the painting of the two lovers. I could then accurately determine how much accenting was needed to give these figures the emphasis I wanted without overworking them and losing a look of freshness. Just a few touches of thick, bright white were enough.

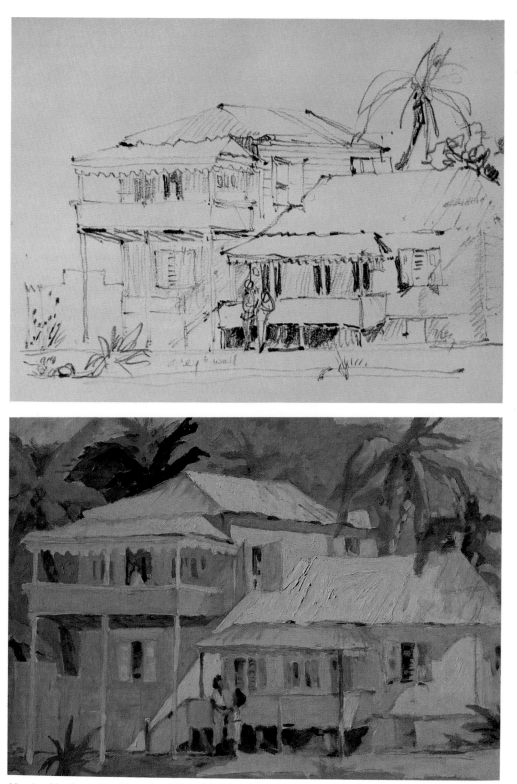

Morning Meeting, oil on Masonite, 20" × 24" (51 × 61 cm)

At the top you can see the texture of the initial panel. This small bit of light sky is important to the painting's mood.

A few touches of impasto bring these figures forward, yet they also blend in with the background shadows, remaining somewhat hidden.

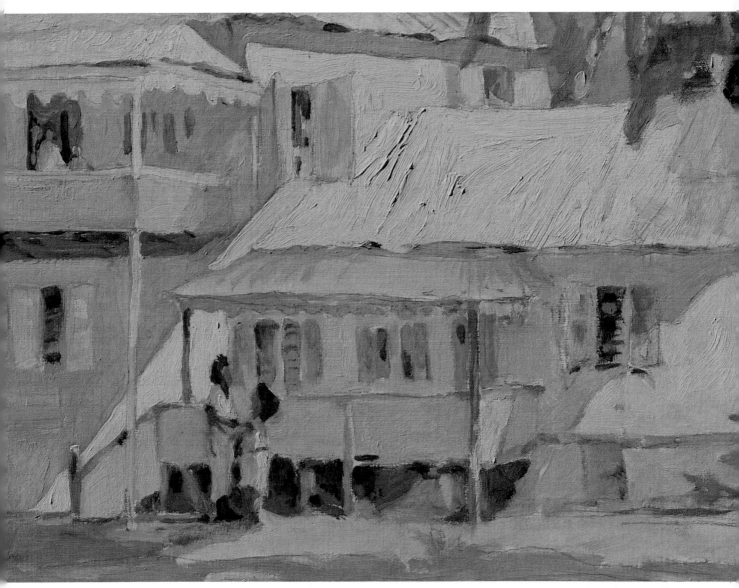

Notice how the angle of the light and strokes of impasto on the roof lead your eyes down to the couple. A few simple strokes were all I needed to define these figures.

8.

DIRECTING THE VIEWER'S EYE

Thick dabs of paint inevitably attract attention, especially if there's a contrast to thinner areas. Impasto can thus be an important compositional tool, helping you tell the viewer where to look. By the same token, you have to think beforehand to make sure thick impasto won't detract from the design, leading the viewer astray. Pay attention to how the paint affects your reading of other artists' work—this should give you clues for your own painting.

Guiding the Eye with Shapes of Light

On a mellow summer day in Maine, this pleasant, restful scene caught my eye. My sketch suggested the idea of using directionals—see how the black accents fall in line, leading the eye? When I got into the painting I thought I would change this idea somewhat, designing patches of white on the buildings to lead the eye to the two figures. The use of impasto to catch the light and direct the eye is similar to what happens in *Straw Hat* (page 45). Once again, it's the thickness of the pigment that calls out for attention.

Working on paper gave me the rich, soft, matte quality I wanted for this scene. I started with the two figures and worked out in all directions from this center point. At first I looked for good shapes on which to "hang" my light. Essentially, the light was invented—used to direct the eye and create ex-citement in the painting. To enhance the lights, I smudged in some well-placed middle tones. Then, squinting my eyes, I located the darks, which also guide the viewer's eye.

Notice the liberty taken with the light roof on the upper right. Also notice the ridge of paint undulating along the treetops above the yellow house on the left. It catches a piece of light and directs the eye toward the figures. Try to imagine the painting without this "light-catcher" and you'll begin to understand its importance.

As you paint, use your brushwork to enhance the directional quality. Look, for example, at the gesture of the brushwork around the figures here. The angle of these strokes continues into the strong impasto highlight on the woman's shoulder—the primary center of interest. Experiment with similar impasto gestures to guide the viewer's eye in your own painting.

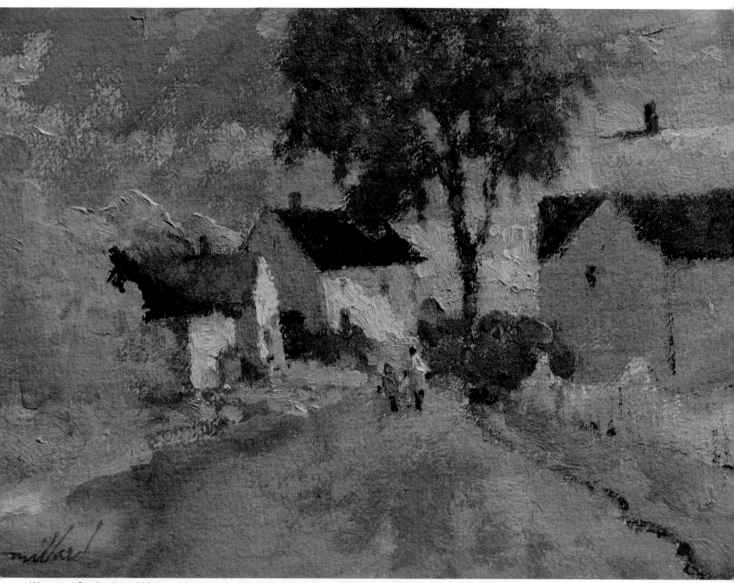

Wiscasett Stroll, oil on 300 lb cold-pressed watercolor paper, 9″ × 12″ (23 × 30 cm)

Emphasizing the Center of Interest

One way to gain attention is to build up the paint around the center of interest. Although the figures in this painting are small, they attract attention because of the thicker paint, especially the white impasto on the mother figure, which catches the light. In addition, heavy impasto catches the light at the top of the tree on the right. As the diagram indicates, there is an imaginary line—one leg of an X—from this treetop through the figures to the light-struck patch of flowers on the left. The other leg of the X runs from the dark side of the barn through the figures to a meadow rock. Geometry and impasto thus work together to direct the viewer's eye.

When you compare the photograph to the painting, you can see that I've raised the perspective so I'm looking down on the farmhouses. Basically, the photograph is a launching pad for my own "invented" scene.

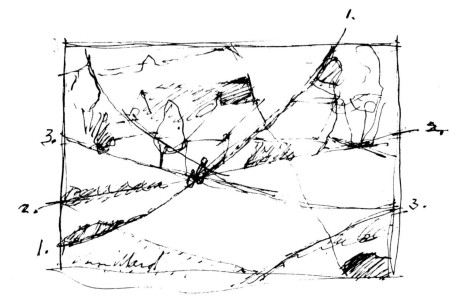

This diagram indicates the underlying structure of the painting. The figures were not accidentally placed; rather, they are a subtle key to the painting's geometry.

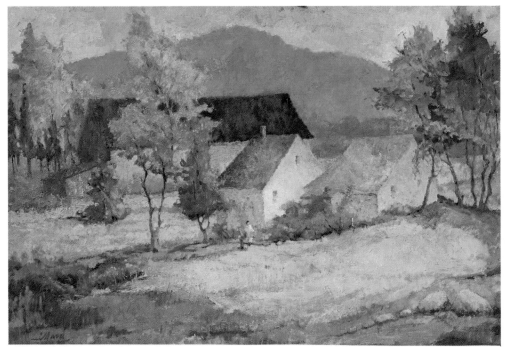

Twin Farmhouses, Vermont, oil on Masonite, 40" × 53" (102 × 135 cm)

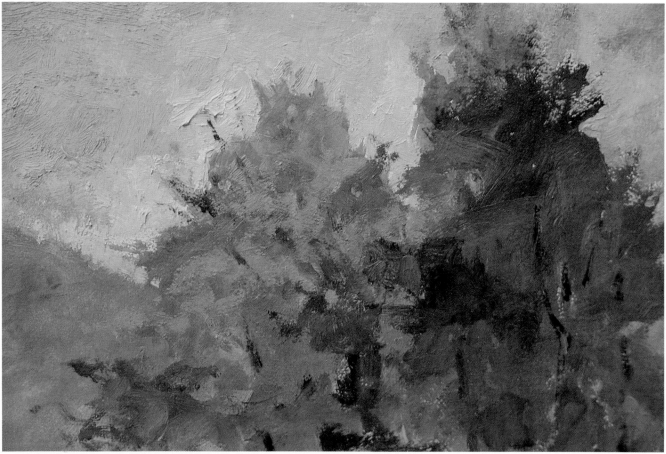

Try to imagine these areas without the touches of impasto. Do you think your eye would be attracted to them quite as much?

Glazing to Improve the Focus

To help focus attention in a busy scene, you might try a toned but transparent glaze like the one I used here. Initially I painted the scene with strong light striking the right side of all the buildings equally. Everything seemed to be shouting for attention, so the viewer didn't know where to look. To bring some order into the painting, I decided to concentrate the light in a single area—around the figures near the entrance to the cathedral. I thus glazed over the entire painting except for the extended wall and a light spot on the cathedral as the sun was shining through a break in the clouds.

When you compare the initial painting with the final version, you can see how much the glaze toned the colors down, darkening many areas and bringing the scattered patches of color together for a more unified look. For the glaze I used a mixture of 1/3 turpentine, 1/3 damar varnish, and 1/3 linseed oil. To a teaspoon of this I added 15 drops of turpentine mixture no. 1, thoroughly shaken at least a day before I used it. I then placed this glaze mixture in my upper palette cup and used it to thin a combination of cobalt blue and raw umber, which I brushed over the entire painting.

In addition to laying in the glaze, I changed some of the strong blue colors, particularly on the building on the left. I also softened and darkened the figures on the road leading up to the cathedral so those near the entrance would stand out. Finally, I added some touches of white impasto (actually a mixture of Grumbacher flake white, with the barest amount of Rembrandt Naples yellow and Winsor & Newton viridian) to the wall in front of the cathedral so that it would project, catching the light.

Before glazing

Ligurian Mountain Cathedral, Italy, oil on Masonite, 9″ × 12″ (23 × 30 cm)

After glazing

Muting Distracting Edges

With oil paint it's easy to adjust the focus of your painting as you work. In this case I built up the entire painting and then realized that there were far too many hard edges calling attention to themselves and detracting from the focus I wanted. By graying the color in these areas and making the touches of paint less distinct, I was able to redirect the eye to the tea tin and pears. Keep in mind that the way you handle both color and texture tells the viewer where to look.

When you compare this photograph with the final painting, you can see that I don't simply copy my subject—I interpret it. Here, I changed the back angle of the tea-tin and shifted the light to create the interest I wanted.

In the sketch, I make much of the way the pears align with the ferns, repeating this angle in other places.

The sharp edges of the ferns, as well as the relatively strong colors in the background and pewter plate, are distracting— you're not quite sure where to look.

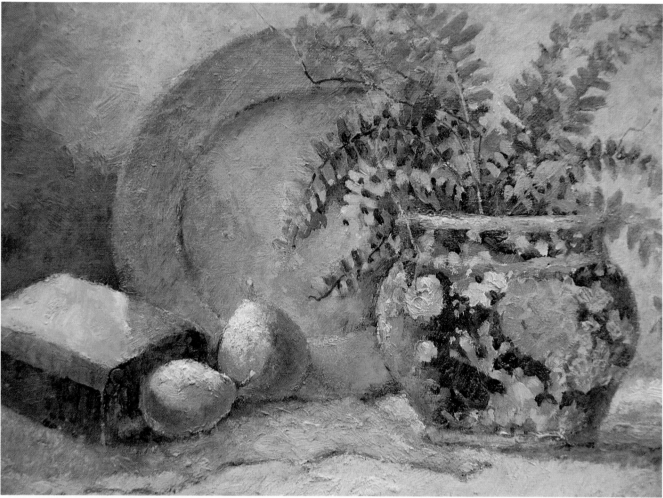

Tea Tin and Pears, oil on Masonite, 16" × 20" (41 × 51 cm)

In the finished painting, the ferns, plate, and background have been muted, so they are clearly subsidiary to the pears.

Notice how the texture buildup on the two pears catches the light . . . and also the viewer's eye. There's a nice contrast in the top of the tea-tin, where the paint was smoothed and flattened with a palette knife.

9.

WORKING WITH DIVERSE TEXTURES

It's amazing how many different textural feelings you can create with oil paint. The best way to learn is to experiment on your own. Work with dry pigments after soaking out the excess oil. Then explore different oil mediums, aiming for thick and juicy or shiny textures. Try changing your painting surface and observe the different characteristics of paper, canvas, Masonite, or mahogany. The paintings in this chapter should get you started; then go on to learn about textured grounds and palette knife effects.

Choosing Objects with Texture and Color

I start thinking about texture and color when I begin searching in the marketplace for my still life materials. In addition to seeing the color with my eyes, I like to actually touch the fruits and vegetables with my hands, coming into direct contact with their texture. As each object goes into my shopping basket, I'm already imagining how I might handle it in terms of color and impasto. The painting thus begins to take shape before I even reach the cashier.

The soft texture of the bougainvillea provided an important contrast to the rough texture of the pineapple. The brilliant fuchsia color was also important, encouraging me to experiment with many different complementary blues and greens, instead of a single green, in the pineapple leaves. Notice how I pushed the hot-pink fuchsia (made with Winsor & Newton permanent rose) to a deep burgundy color on the left. This makes the light on the right all the more brilliant.

Initially, I thought I would keep the two oranges the same value, but then I decided to include a wave in the background. Since too much bright orange paint would have upstaged the wave, I made the second orange a pale green ochre and kept the paint relatively thin. To create the wave, I first removed some of the oil from Winsor & Newton foundation white by leaving it on a brown-paper bag for 15 minutes. Then, using my Winsor & Newton palette knife (no. 4), I whipped it together with Shiva under-

Pineapple, oil on Masonite, 7½″ × 9¼″ (19 × 23 cm)

painting white until it held in stiff peaks. I applied this to the painting and then rounded the peaks off to catch the light.

I deliberately painted in a gutsy sky to go with the rough pineapple texture and heavily pigmented wave. A flat, thin background would have fallen on its face. To make the sky dance with emotion, I used my Mussini flat brush (Grumbacher Series 4227) to manipulate the impasto and turned to a Wharton long bristle for the thinner scumbling. Choosing the right brush can make a difference in the texture of the paint.

Contrasting Thicknesses of Paint

Although I may use a photograph for reference, I don't paint what the camera sees—instead, I use my artist's eye to redesign the shapes and create the emphasis I want. Here I concentrated my impasto accents on the blue balcony, keeping the paint relatively thin elsewhere in the scene. Notice how the wall of textured raw sienna intensifies the center of interest and also helps to unify the intricate details of the balcony. There's also a secondary interest in the richly textured triangular roofs that lead the viewer's eye up and into the background depth.

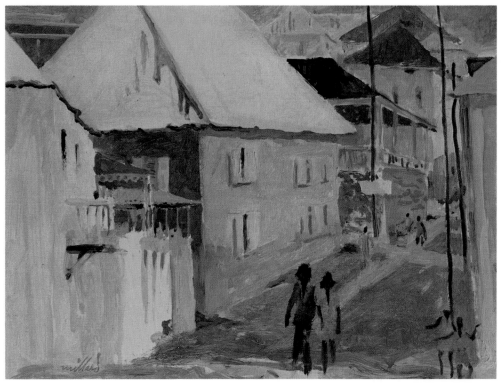

Blue Balcony, oil on Masonite, 12″ × 16″ (30 × 41 cm)

To prepare my panel, I used two coats of fine-grid textured flake white priming over the sanded Liquitex gesso, letting the first coat dry for two weeks and the second for a month. I was then able to leave parts of this white ground exposed in the final painting as pieces of the white design.

For the first layer of impasto, I aimed for a slightly grainy effect, using Winsor & Newton flake white no. 1 (with a pear-flesh-like texture) in a thin, soupy turpentine mixture no. 1 and allowing it to "drool" and run down the white building and under the blue balcony. After these drools dried, I enhanced them with additional impasto.

To give an atmospheric quality to the blue balcony, I used rough brushwork, scrubbing on the dry impasto with a small round brush. This technique is especially evident in the wall of raw sienna (LeFranc & Bourgeois terre de sienne naturelle) behind the balcony. I also used the scrubbing technique on the two figures in the foreground.

For the complex roof pattern, I used a heavier impasto, with a bit of oil medium no. 1 added to my pigments. The richness of the impasto in these roofs thus serves as a counterpoint to the blue balcony. Also notice how the long, skinny telephone poles repeat the balcony roof posts.

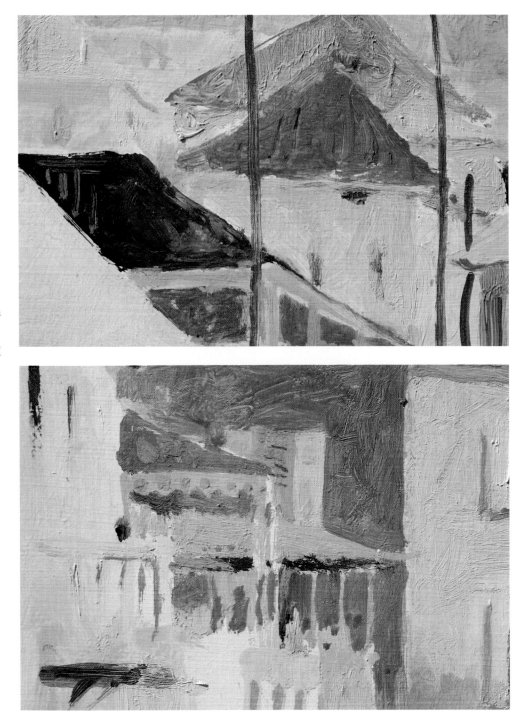

Figures can be 90 percent background . . . stay loose!

I pick at the figures to make them grow into reality.

95

Weaving a Tapestry-like Texture

At first glance this picture may seem very busy, but the handling of the impasto and the division into a warm and cool side help to organize all that's happening within. Essentially the horizontal and vertical strokes of impasto weave the whole together, much like a tapestry. The thicker strokes of pigment catch the light, like heavy woven threads. Also notice how the vertical edges of the houses reinforce the up-and-down flow of the hill, in counterpoint to the triangular roofs.

Impasto textures remind me of the creative arrangement of musical notes. When I first look at a subject, it strikes a certain rhythm through its pattern, light, and color. More often than not, I interpret it as a painted piece of music.

Here I chose Winsor & Newton flake white no. 1 as my basic white. For the early stages, I removed some of the oil from the white by letting it sit on paper for about 10 minutes, but later, for the heavier buildup of impasto, I left the oil in.

To understand how impasto can suggest space and bring a scene to life, take a look at the balcony on the left with the yellow figure. It isn't only the light-dark contrast that makes this balcony seem to hang out in space, but also the direction and texture of the brushmarks. Now focus on the figures on the road. Notice how the thicker purple drape and white turban pull the woman in front forward, toward the viewer, so you can feel her moving toward you. The other more thickly painted figures also move forward, away from the thinner areas of paint around them.

The transition from the cool side to the warm side of this painting creates a back-and-forth movement throughout. Also, the verticality of the hill, sides of the buildings, and up-and-down look of the figures weaves a visual pattern with the strong horizontal accents of the many roof eaves like the warp and woof of weavings or point and counterpoint of music.

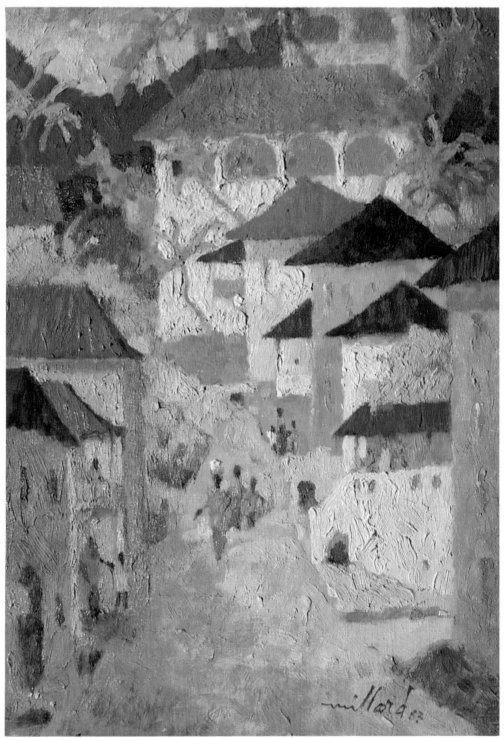

Synagogue Hill, oil on Masonite, 12" × 9" (30 × 23 cm)

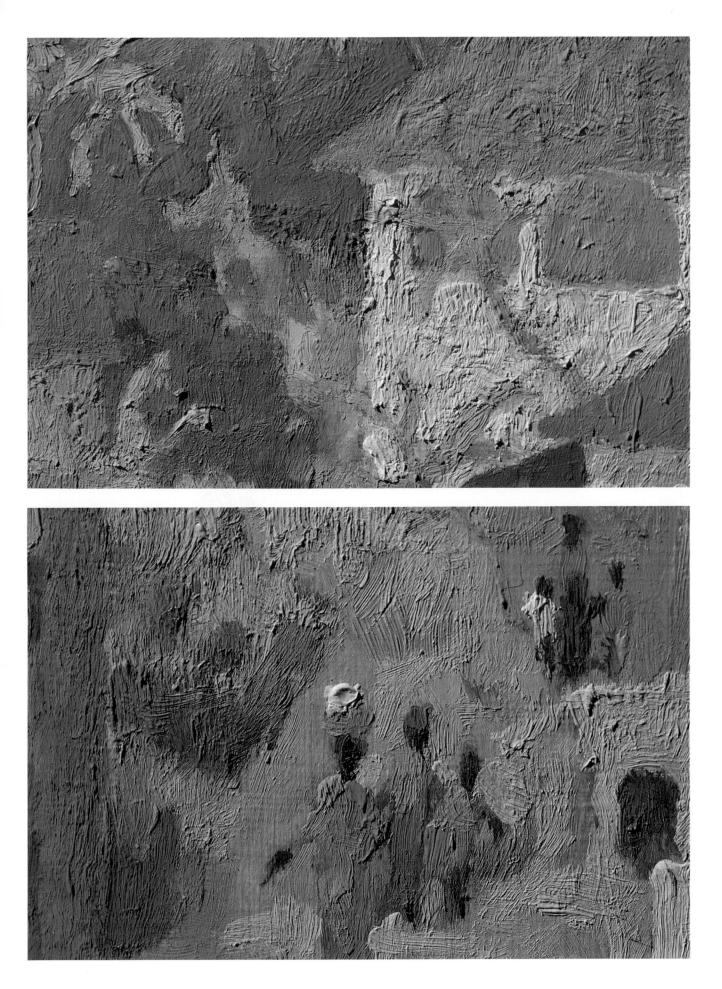

Obtaining a Pastel-like Quality

One of the wonderful aspects of oil paint is that there are so many different ways you can work with it. Here I built up the painting in layers, working in my usual way. But then, when the painting was complete, I scraped it down with a palette knife to get a soft, matte finish, similar to a pastel. Sometimes removing paint can be just as effective as applying it (see also *Still Life on a Carpet*, page 74).

When I squinted at the scene, this tabletop in a Venetian restaurant seemed to be joined as a mass to the diners beyond. That's how I sketched it on the site. Later, in St. Thomas, I used my sketch for a watercolor demonstration for a class. Thinking about the scene that night, I decided to rework it in oil, aiming for a pastel-like quality.

After sketching the composition in carbon pencil on a piece of shellacked museum board, I fixed the drawing and then stained the surface with a wash of orange and burnt sienna to get a warm ground. Using a paper plate for my palette, I dried out my oils and began to develop the painting with thin layers of dryish color. Gradually I built up the pigment in the light areas, leaving the shadows as stains. Then, after waiting 30 minutes, I scraped off the entire surface with a 2-inch (5-cm) palette knife, which gave me a soft-edged, pastel-like effect.

As a final step, I applied some thicker paint to the highlights on the pears, the tablecloths, the necklace, and the earring. I took care, however, to avoid any telltale glisten that would interfere with the pastel-like quality of the whole. When everything had dried, I framed the painting under glass to protect it, just as I would a pastel.

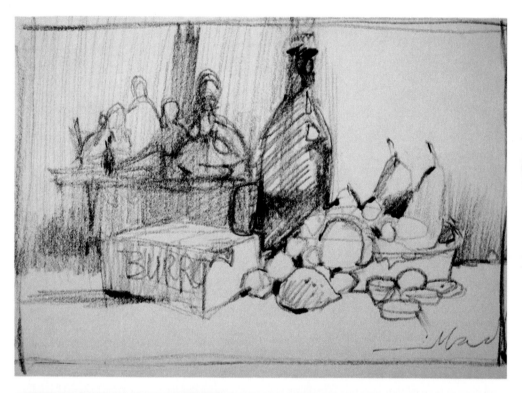

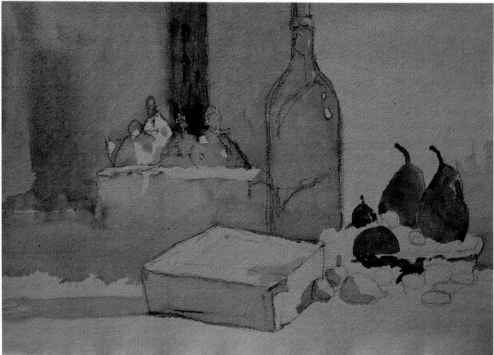

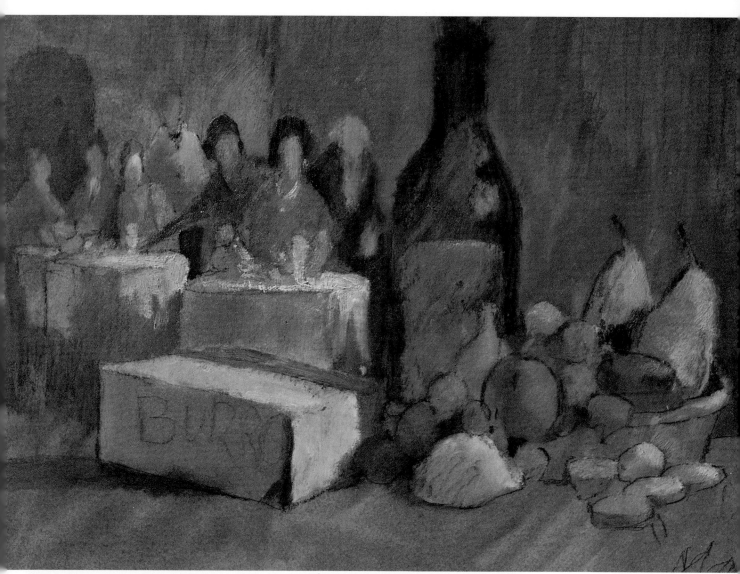

Burano Burro, oil on museum board, 10″ × 13½″ (25 × 34 cm)

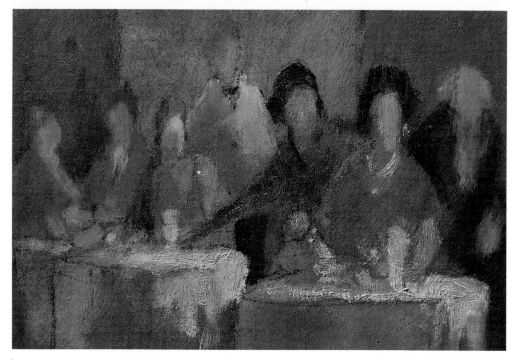

Taking Advantage of a Wood Panel's Texture

There was a wonderful glow to this after-supper summer light. The figures seemed to almost merge into the shadows under the great tree, except for the two ladies at the edge, who caught the last rays of sunlight. To capture these subtle nuances of light, I chose a mahogany panel rather than a canvas weave. If you look closely, you can see the wood grain showing through in places, especially under the left branch of the tree. This texture goes along with the bits of light-colored ground shining through the grayish shadows . . . which is what gives this painting its inner glow.

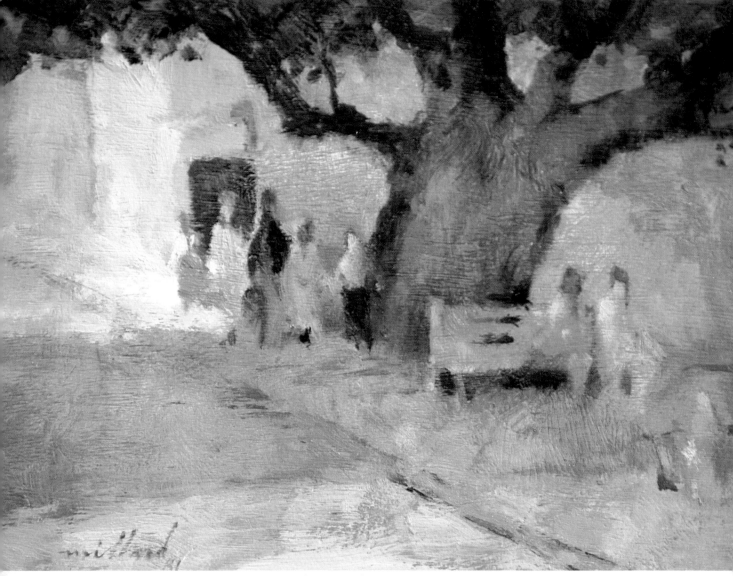

The Meeting Tree, oil on mahogany panel, 5¾″ × 7½″ (15 × 19 cm)

This small painting was built up gradually, over a week, from the darker tones to the lightest lights. If you look at the detail, you can gain some idea of the process. The first step was to rake out the grain of the wood panel with a wire brush; then I rubbed a light mixture of raw umber, yellow ochre, and Grumbacher flake white across the grain as a ground tone. I scumbled a thin, smoky blue over the shadow areas, letting the ground show through in places. Later I used my thumb to remove some of the pigment from the sides of the tree and above the doorway, letting even more of the ground peek through.

To keep the edges of my darks soft, I used an old, roughened round bristle brush. At times, I also used my fingers to blur the edges. (Remember to always wash your hands afterward with soap and water—twice!) Although the shadows are quite dark in places, they are never harsh, in keeping with the mood I wanted.

For the bright, sunlit patches I used creamy combinations of yellow ochre and Naples yellow. Here and there I added accents of bright color in somewhat thicker paint to clarify the figures and bring them forward a little, so they wouldn't become lost entirely in the ethereal shadows. Finally, I put in the touches of impasto on the shoulder of one woman and elbow of the other woman on the left and the knee of the woman on the right to show how the last rays of light pick out certain forms.

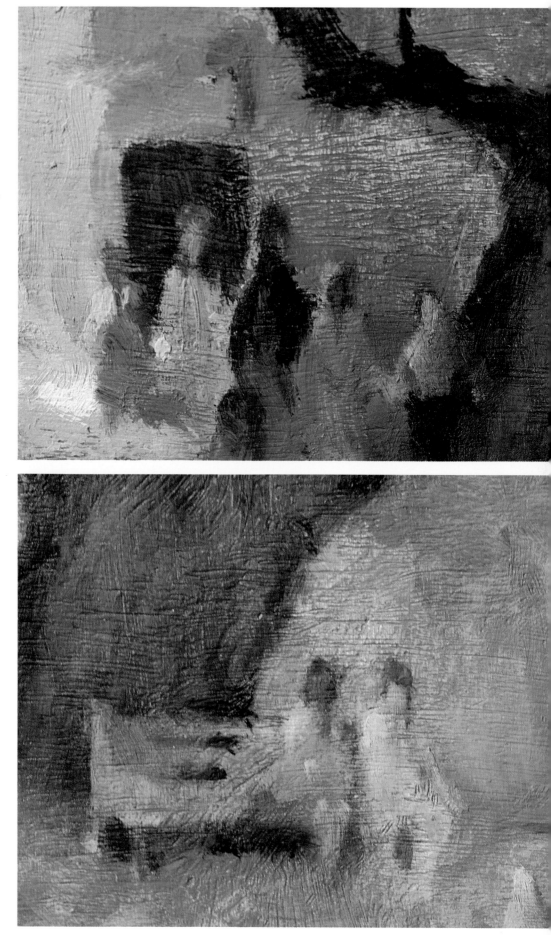

Playing with Subtle Texture Contrasts

A painting should work on several levels, holding the viewer's interest both at a distance and as he or she moves in for a closer look. Here, the immediate message is carried through the strong light-dark pattern and lively color, but it is the subtle impasto passages that attract attention with a more intimate, close-up view. The more you look, the more you realize how many different layers of color and texture there are—and that has a lot to do with the rich, jewel-like feeling of the painting as a whole.

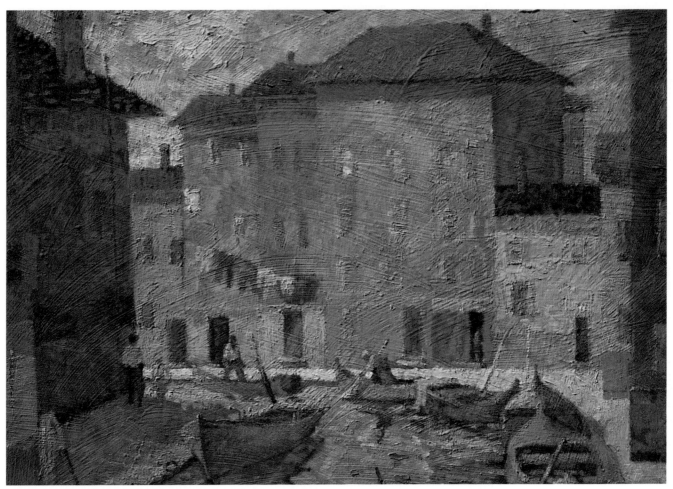

Burano, Morning Chores, oil on Masonite, 24" × 30" (61 × 76 cm)

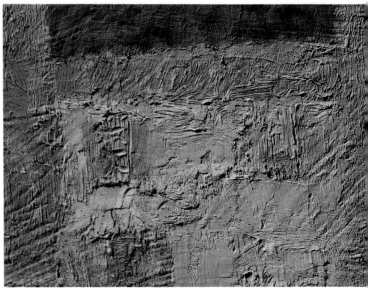

Here, the overlay of impasto in the sky sets up vibrating edges with the underlying soft-ridged texture of the ground. The building on the right seems relatively tranquil, yet it is rich in impasto contrasts.

In the upper area of this building, I used a creamy paste to fill in the striated brushmarks from the ground. I added a touch of Winsor & Newton permanent rose to Bellini Venetian red, whipped this with my white and turpentine, let the mixture dry out for 30 minutes, and applied it with a brush. After letting this sit for 30 minutes, I touched it with a no. 2 palette knife to get rid of some of the brushmarks; after another 10 minutes had passed, I lightly "thumbed" the edge marks of the knife.

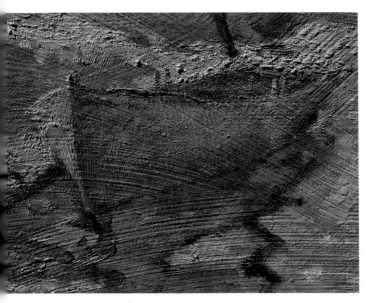

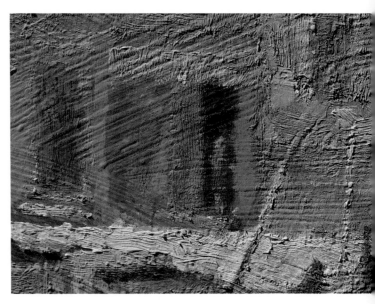

The color and texture work together here to define the form of the boat and suggest the sparkle of sunlight on it. Compare the intense yellow nodules of paint near the back with the more muted color and flatter texture along the shadow side of the boat.

Compare the subtle figure in the doorway here with the heavy impasto gesture on the quay.

Painting Buttery Impasto Directly

As a change of pace, it's a good exercise to do a small painting with a one-hour time limit. Working quickly in this way may encourage you to experiment and to feel freer in applying the paint. It can be fun to work with thick, buttery impasto within this limited time span—working *alla prima*, instead of building everything up in layers. Although you won't get the jewel-like color vibrations of a painting like *Burano, Morning Chores* (page 102), you can get an exciting energy through vigorous brushwork.

Before I did this painting, I had done a dozen carbon-pencil sketches of the subject to demonstrate to my class the many different compositions possible. For this quick impasto study, I chose a panel with a ground color of raw sienna and cadmium orange and a stipple finish, providing good adhesion. To get my class to think beyond the usual blue sky–green grass landscape interpretation, I decided to experiment with color and selected Liquitex bright aqua green for the sky, lavender for the trees, and red for the foreground grass.

Notice the different rhythms of the brushstrokes in the bridge, trees, sky, and water. The thick impasto on the bridge is solid without being sharply accurate at the edges, suggesting the ancient stone texture. When I applied these brushstrokes, I was actually thinking: "massive . . . solid . . . rugged." In contrast, while painting the water, I was thinking: "flowing . . . moving." The point to remember is that when you're working with such heavy impasto, there's a bit of magic in each stroke—think, to get the most out of it. I often wonder what Van Gogh thought as he worked his magic.

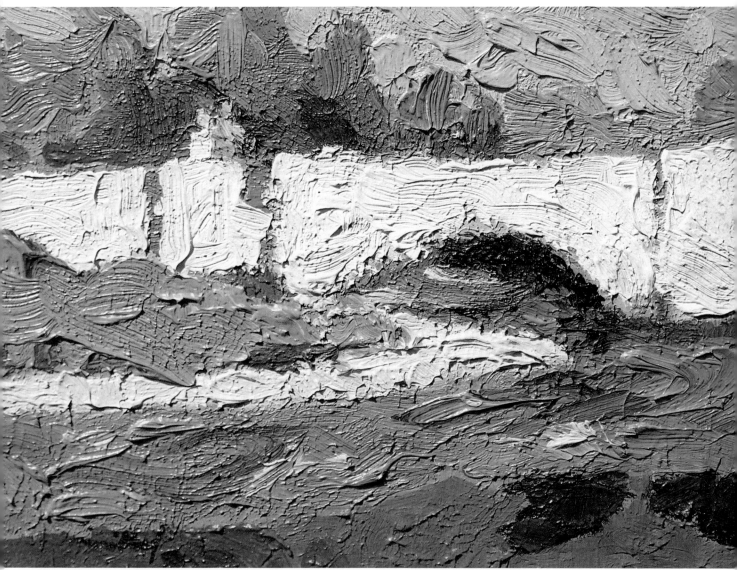

Dover Bridge, oil on Masonite, 5″ × 7″ (13 × 18 cm)

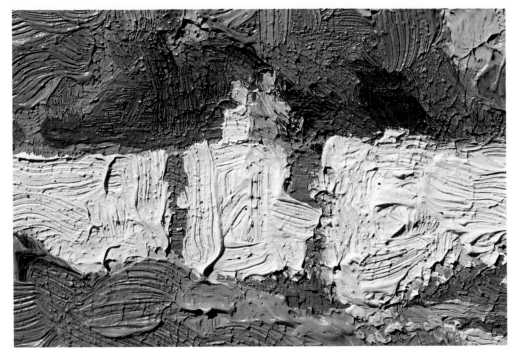

10.
STARTING WITH A TEXTURED GROUND

In the beginning of the book I demonstrated various ways in which you could create textured grounds (see pages 19–23). Now it's time to take a closer look at how to use these grounds in a painting. One of the things I enjoy about a background texture is that it has a rhythm of its own that comes through. Any layers of paint that I apply on top become a kind of counterpoint.

Painting a Portrait on a Textured Ground

My neighbor Mr. Page's alert appearance and strongly delineated features encouraged me to experiment. The rugged ground seemed appropriate to his character, but I also wanted to suggest warmth and sensitivity in the way I built up the forms of the head. There were a lot of times when I was flying by the seat of my pants, without the foggiest notion of how the painting would turn out. The point is that it's important to take risks and invent as you paint, yet be guided by your sensitivity.

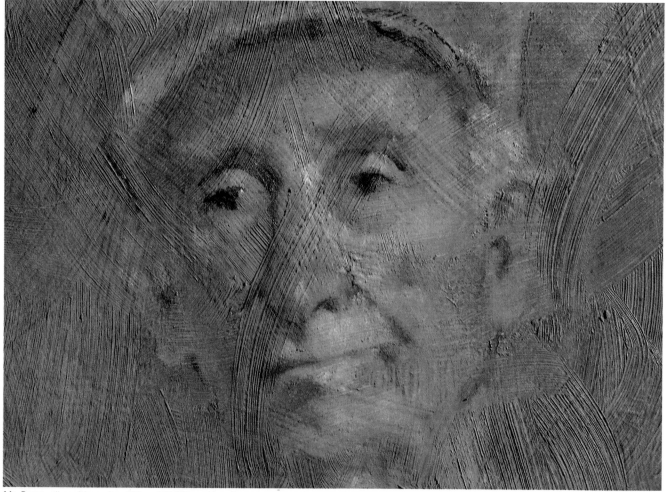

Mr. Page, oil on Masonite, 12″ × 16″ (30 × 41 cm)

For this portrait, I selected a panel with a sharp-ridged, striated ground, colored with Grumbacher terra rosa. After sketching in the basic head with a turpentine wash, I began to fill in the ridges forming the head, using fairly thin paint. I was gradually building up the image, modeling the darker indentations and lighter prominences, molding the form like a sculptor.

Taking a deep, warm dark, I filled in the eye sockets and then went on to paint the recessed dark area between the eye and the nose, as well as the shadows under the nose and mouth. Now I was pushing paint down into the crevices, building up the flesh of the cheek, the bridge of the nose, and the area above the lip. My excitement rose as I felt the painting coming closer to the solidity of the head before me.

Toward the end I decided to try Rembrandt Chinese vermilion for the red highlights on the bridge of the nose and around the left eyelids. Then, as a final touch, I added that one bright speck on the left eye. It's not white, as you might at first think, but pink.

Letting the Ground Add Character

In addition to providing good adhesion for additional impasto, the stippled texture of the initial ground helps to establish the country character of this painting. Although it's possible to imagine this rural Vermont village painted on a flat panel, the rough texture lends it a rugged, rural feeling. As you gain more experience with textured grounds, you'll be better able to judge which ground goes best with which subject. But don't be afraid to experiment. Sometimes the best paintings result from trying out something you don't initially think will work. Take a chance!

Waterville Barns, oil on Masonite, 9" × 12" (23 × 30 cm)

The ground for this painting had a stippled texture, with medium-height meringue-like peaks. I continued this rough impasto feeling in depicting the actual scene, applying lumps of paint with my brush and even adding grains of sand in places.

My white was Permalba white, with the oil removed by letting it sit on a brown paper bag for 20 minutes. I then used oil medium no. 3 to obtain a tacky impasto texture. This medium also provided good adhesion with the ground support.

Because I wanted to use a lot of relatively thick, gestural impasto, I kept the forms and colors fairly simple, without too much detail. Notice how the gesture of the paint conveys the scudding movement of the clouds. Also notice the swirling silhouette of the dark trees, enhancing the feeling of movement in the sky.

Using a Multicolored Stippled Ground

Following the examples in the technical section (page 22), I decided to create a textured ground using pigments from my daily palette. As I covered the panel with these colors, I was in a sense creating an abstract painting. This process is very experimental, but it can be a lot of fun. A major advantage of painting on a ground like this is that it takes you out of your normal routine and "forces" you to see differently. Although it can be a challenge to make a more realistic scene work with this ground, it's worth the effort.

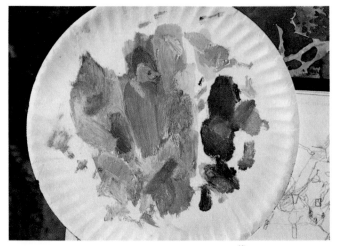

These are some of my palette colors used for the background.

Here you can see the ground with my initial sketch.

To prepare the ground, I mixed my palette colors with Grumbacher flake white and put them down over a period of two weeks, gradually building up the texture. To create the stippling, I patted the paint with my painting knife, making a series of meringue-like peaks. These peaks would provide a strong bonding surface for later applications of paint.

After letting the stippled ground set for two months, I sketched in a Venetian street scene, using Rembrandt ultramarine blue and Liquitex dioxazine purple mixed with a touch of oil medium no. 5. I darkened some of the buildings to clarify their forms and the perspective. Then I added some dabs of rich impasto in the foreground, leading up to the bridge. But, for the most part, the texture you see comes from the original stippled ground.

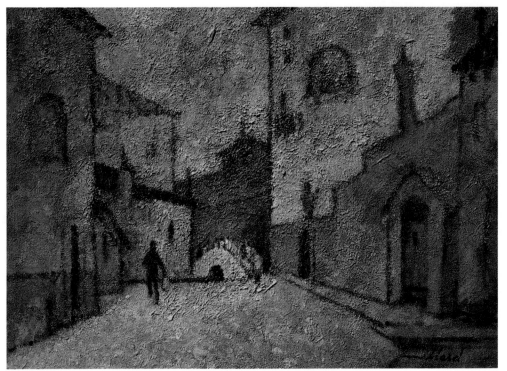

Ramo del Forno, Venice, oil on Masonite, 12″ × 16″ (30 × 41 cm)
Finishing the painting was mainly a matter of tuning up the darks.

Small touches like the two blues defining the windows add to the painting's sparkle.

About 90 percent of what you see here is the original ground.

The texture of the initial ground suits the subject, enabling you to almost feel the walls.

Working Color over a Striated Texture

A sharp-ridged ground texture with striated brushmarks gives me a variety of options in applying color: I can add a thin stain on top, letting the brushwork show through, or fill in the voids, or drybrush paint across the crevices. All of these techniques are evident in this seascape. Together they make for the exciting back-and-forth, in-and-out movement that draws the eye into looking and looking again at this painting.

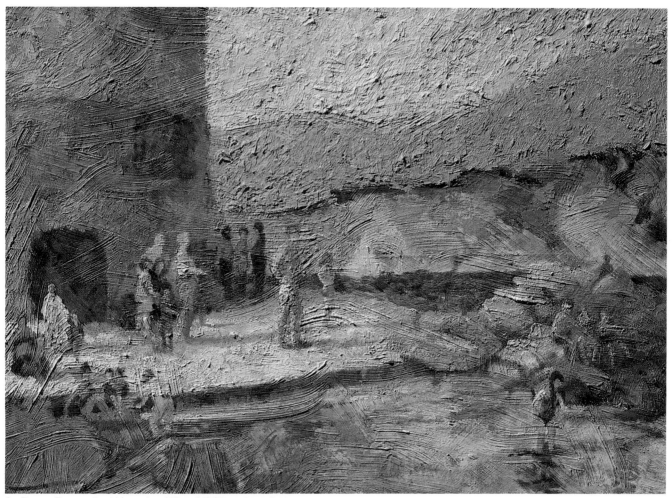

St. Tropez Tower, oil on Masonite, 20″ × 24″ (51 × 61 cm)

After creating the sharp-ridged ground, I rubbed on some terra rosa thinned with turpentine mixture no. 2. You might compare this painting with *Mr. Page* (page 106), which also uses a sharp-ridged ground stained with a red earth color.

To create the figures here I first blocked in the under-color I wanted, filling in the shape of the person and taking care to push the paint down into the valleys. Some of the figures were left thinly painted in bluish hues to give a soft, shadowy effect. Other figures were built up with touches of impasto, catching the light. Look, for example, at the arm of the figure with the green shirt pointing toward the crusty white swim trunks of the figure in the center.

The sky and pink mountain were textured with meringue peaks, with layers of paint brushed over this. The distant sea cliffs, on the other hand, were painted differently, with impasto worked into the sharp ridges and touches of dryish pigment added with a palette knife. Throughout, there is a layering of color—as in most of my paintings—which adds to the in-and-out movement of the whole.

Compare the meringue-like peaks of
impasto in the pink mountains with the
palette knife textures in the sea cliffs.

A few touches of color can be enough to
suggest figures. You don't need a lot of
detail.

Notice how the thick impasto on the
figure's arm attracts attention and directs
the eye to the central figure (in the white
swim trunks).

Using a Heavily Textured Ground

For this painting, I used a heavily textured ground, with meringue-like peaks and some palette knife work. The strong underlying impasto texture helped to unify the painting, no matter what colors I chose. That's not to say I didn't take care with my colors. The burnt orange outline color became a key to which I related all the other colors. I also experimented with color vibrations, especially in the background, where the original turquoise shows through the red.

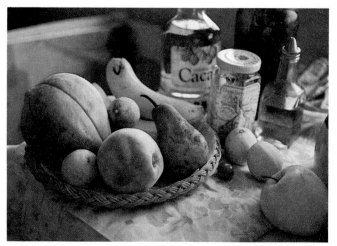

To some, this photograph might have suggested a painting with a smoothly finished surface and a tight, realistic interpretation. Instead, I focused on the shapes of the objects and then experimented with invented texture and color.

This initial heavily textured ground accounted for a good percentage of the final surface texture.

There are a few notes of caution to keep in mind when you're working with heavy impasto. In particular, I am mindful of the cardinal rule: fat over lean. At the very start, I remove any excess linseed oil from my whites by letting them sit for 15 or 20 minutes on brown paper. If I begin with a lean base, I feel I have more control in adding oil a drop at a time as I need it, as I progress.

After I finish a painting with heavy impasto like this one, I let it dry for six months to a year before framing it under glass (to protect it from grease). Often I use my thumbnail to test for any remaining softness.

The background was first painted a turquoise color, but I later painted over it with a vibrant red, adding a lot more excitement to the still life.

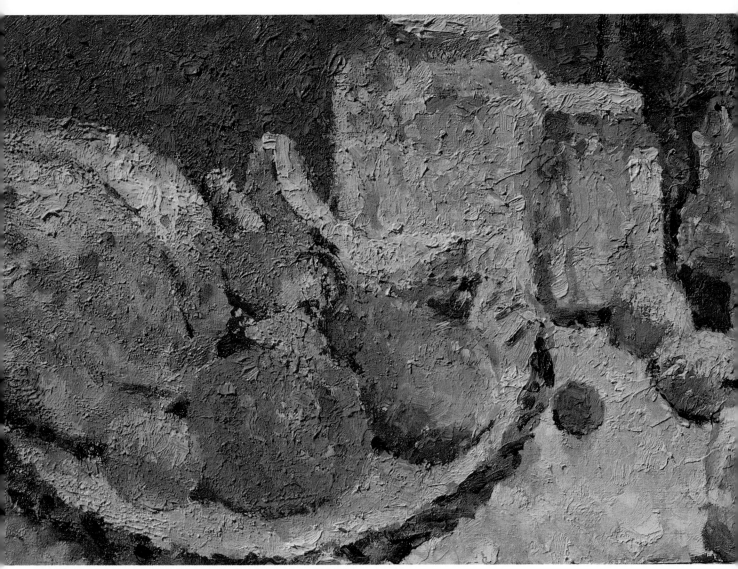

Gooseberry Chutney Jar, oil on Masonite, 9½″ × 14¾″ (24 × 37 cm)

Here you can see the original turquoise background breaking through the red and setting up lively vibrations.

Even though this pear is a purplish blue, it's clearly a pear because of its shape. Notice how the strokes of impasto help to define the form.

11. EXPERIMENTING WITH A PALETTE KNIFE

When I saw the wonderful way Cézanne used a palette knife in two paintings in the Louvre—*The Blue Vase* and *Onions and Bottle*—I decided to spend some time to acquire a working knowledge of this tool. If you've never tried using a palette knife to touch or spread your paint, you're in for a treat. As the six paintings in this chapter show, there are a variety of ways to use the blade—flattening the paint, scraping it off, troweling it on, and more.

Altering the Existing Brushwork

For me, it's always a joy to set up a still life with contrasting textures and then try to interpret the excitement in front of me by varying the handling of the paint. In this case, I built up most of the painting with different size brushes. Then the lighting changed on the seashell, so I reworked that area with a palette knife, creating a different kind of accent. I like to remain open to changing conditions as I paint, with the freedom to change earlier impasto commitments.

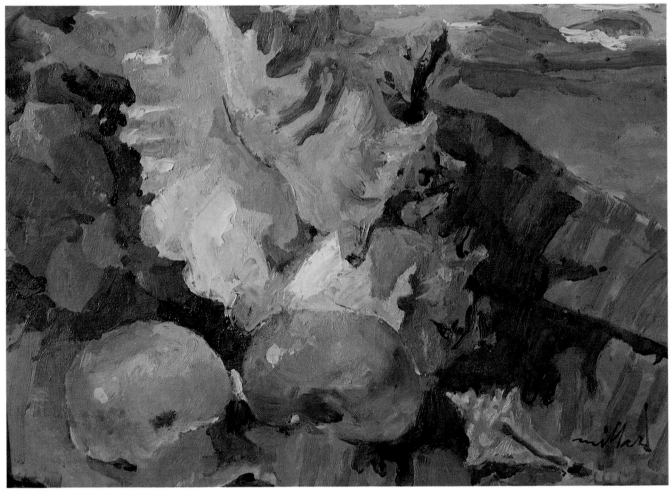

Conch, Hibiscus, and Mangoes, oil on Masonite, 12" × 16" (30 × 41 cm)

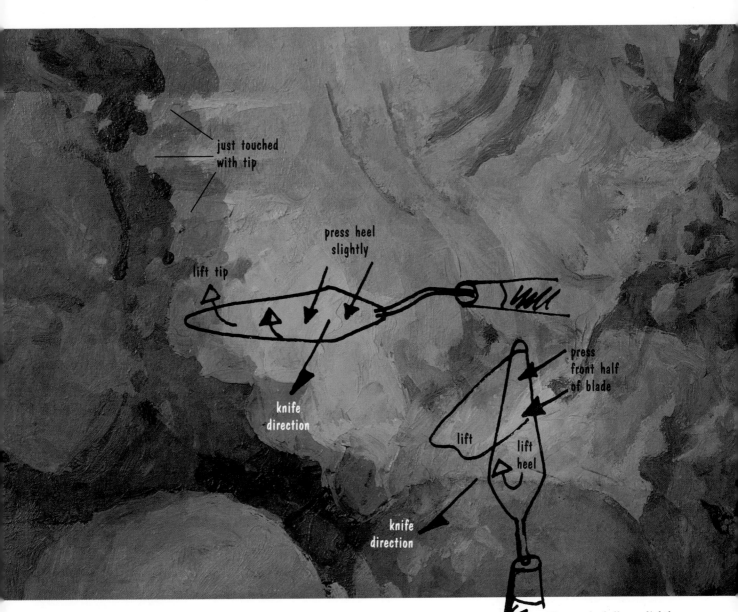

just touched
with tip

press heel
slightly

lift tip

knife
direction

press
front half
of blade

lift

lift
heel

knife
direction

This *alla prima* painting was done as a morning's class demonstration. I worked with my flat bristle brushes, starting with a no. 8 for the lay-in and using turpentine mixture no. 1 as my thinning agent. After leaving the painting for a half-hour to let the turpentine evaporate, I eagerly began applying thicker paint with brush nos. 6, 5, and 4, reducing the size as the work became more detailed. Within an hour, the basic brushwork was complete.

As the class continued to paint, I let the painting set for another hour. When I went back to check it, the light had changed, creating an exciting glisten on the seashell. To capture this, I took my palette knife and stroked the brushmarks in the manner indicated in the diagrams on this page. Just a few touches of the knife conveyed the light's magic.

The conch shell was lightly touched with my Winsor & Newton knife (no. 4 on page 12) after the completed painting had "rested" 20 minutes. The paint was already there; it was not put on with the blade.

Adding a Strong Impasto Accent

This painting offers a strong contrast in textures, from the thinly painted, almost textureless void of the foreground plaza to the highly textured stucco of the mission buildings. In highlighting the sunny white facade, I used a few quick touches of a painting knife to make this area stand out not only because of its brightness, but also because of its texture. For a quieter texture on the building behind, I used the knife in a different way (see the diagrams).

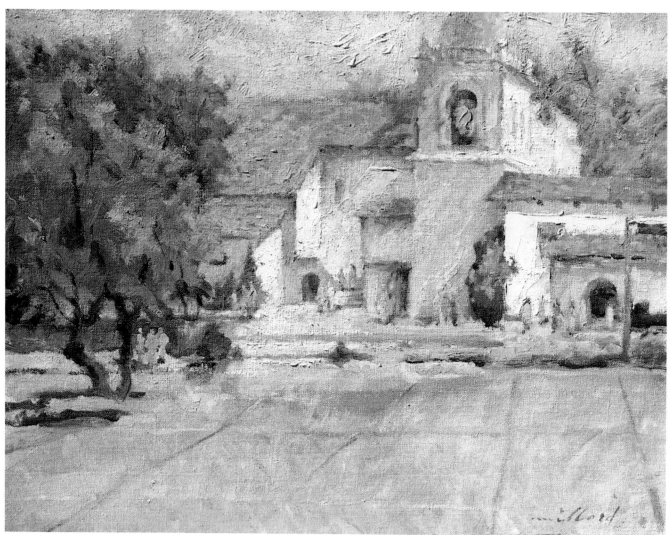

Carmel Mission, oil on linen, 14" × 18" (36 × 46 cm)

Initially, when I laid this painting in, I thinned my paints with turpentine mixture no. 1. Then, in building up the foreground, I added a drop of linseed oil to a teaspoon of the turpentine mixture. For the sunlit buildings behind, I chose Winsor & Newton foundation white and removed the excess oil by leaving it on a brown-paper shopping bag for 20 minutes. I then mixed it with oil medium no. 1, which restored some of the binding quality of linseed oil but gave me control over the surface finish. At first I worked different colors of white into the mission walls with my brush. But then, to add the intense white impasto, I used my Langnickel painting knife. I also touched up some of the other walls with the knife to give them a stucco texture.

Notice how the figures in this scene are located in the middle ground, bringing the contrasting foreground and background together. In doing this, I thought of how Bonnard would pose a figure behind a table in a scene in which there was a large tablecloth area that was almost textureless, while—in contrast—the fruit in the bowl was built up with many brushstrokes.

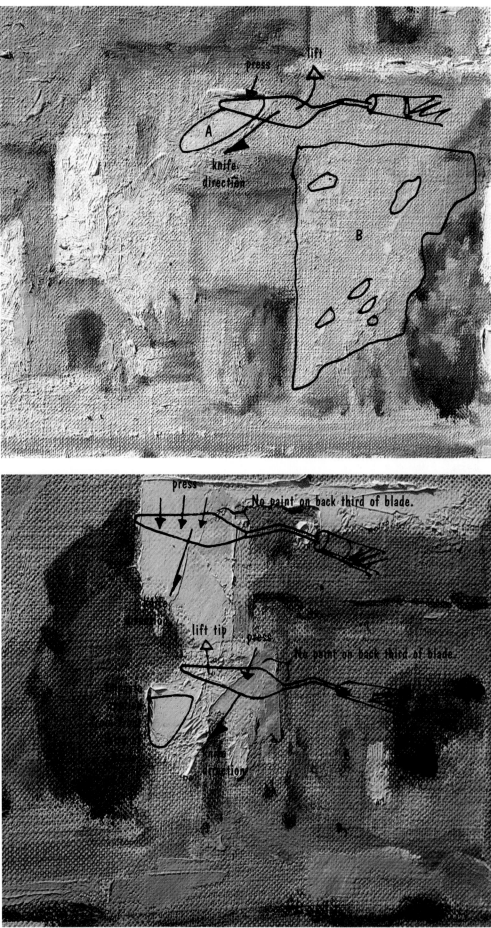

No pigment was added with the knife here. In section A, I let the impasto rest for 30 to 40 minutes; then I barely touched it with the blade of the front half of the tip of my no. 2 knife (see the chart on page 12). I let section B set for one to one and a half hours; then I touched it just enough for a stucco effect.

Here I added white impasto on top of paint that had set for 40 minutes, using my no. 2 knife (shown on page 12).

Creating Different Textures of White

This Maine housewife was hanging out the wash when a sudden break in the clouds produced a bright splash of sunlight. The way the white pants lined up with the patch of strong sunlight on the building appealed to my sense of whimsy, and I decided to play with this in my painting. The challenge was to distinguish the white clapboards of the house from the white of the pants and yet have the two read together, as one large shape. That's where my palette knife came in handy.

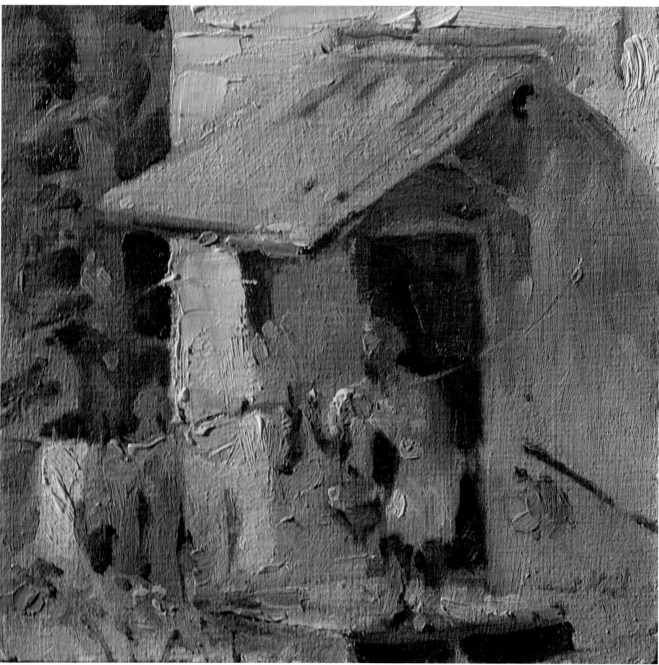

Pine Tree Laundry, oil on Masonite, 8" × 8" (20 × 20 cm)

Working on a cross-grained Masonite panel, double-primed with Benjamin Moore's Sani-flat (alkyd) white, I completed about 90 percent of this painting in an hour. Since the Sani-flat surface was rather dry and absorbent, I skipped my usual turps wash and began with oil medium no. 1. This gave me an eggshell finish, adding life to my darks.

Once everything was down, I stepped back to study what I had done and let the paint set up for about 20 minutes. Adding a drop of linseed oil to my palette cup for a richer medium, I then went over the entire painting, introducing touches of heavier impasto color . . . from the dark negative shapes around the pine tree to the thick whites (made with Grumbacher titanium and zinc white) on the towel, top of the pants, and sunny side of the house. After the white impasto had set up for 15 minutes, I took my palette knife with the 4-inch (10-cm) blade (no. 7 in the chart on page 12) and scraped the paint as shown in the diagram, drawing the knife down sharply at a 45-degree angle. After each downward stroke, I wiped the blade clean—except for the last time, when I touched the loaded blade horizontally across the surface in two places to indicate the clapboards.

There's another important impasto touch in this painting. Notice the thick orange globules of the lilies at the bottom left. These dabs help to alleviate the starkness of the pant legs and keep them from rushing down and out of the painting.

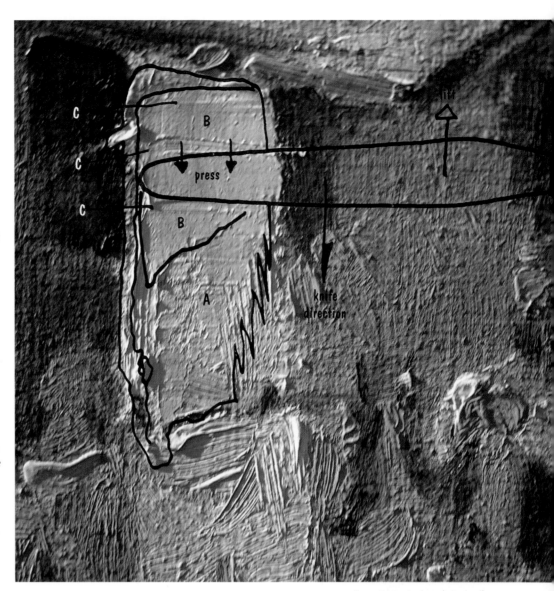

In section A, heavy impasto was first applied with a brush—rather dry but thick. In section B, I did a downward swipe with my no. 7 knife (shown on page 12) to smooth the brushmarks, using the 1-inch (3-cm) tip. Then, after wiping the blade clean, I knifed in the horizontal clapboards at points C.

Troweling Rough Impasto Textures

From the start I was intrigued by the play between the roughly textured hospital walls and the tenderness of the mother cradling her child. By troweling the paint on with my knife and adding a few pinches of marble dust in places, I was able to re-create the feeling of stucco walls. This rough tactile quality contributes to the painting's "bite" . . . and it invites you to reach out and touch the mother with her child.

Nurse, Mother, and Child, oil on Masonite, 8" × 9" (20 × 23 cm)

Although the hospital walls were actually white, I used different colors and textures to create the design I wanted, structuring the painting with four simple rectangles. After brushing in the mother, I chose dark blues for the doorway to make the child's head stand out. But I didn't want to separate the mother too sharply from the background, so I allowed her hat and back to merge into the warm earth color of the rectangle on the right. For the balcony below, I chose a cool gray. To stiffen the paint, I soaked out the excess oil by leaving it on a brown-paper bag for 15 minutes; then I scrubbed it across the surface using an old El Greco no. 12 round bristle brush. Finally, for the fourth rectangle—the roughly textured wall behind the nurse—I troweled on the paint, building up layers of quite dry impasto with my 2½-inch (6-cm) knife (no. 5 on page 12).

Working with these rich impasto textures was a bit of a balancing act, involving a back-and-forth dialogue between the two main figure groups, as well as the figures and the background. In working on the nurse, for example, I found that she began to upstage the mother and child, so I "lost" her somewhat in the next layering . . . only to bring her out again later by knifing in accents on her hat and arm.

By painting both the nurse and the wall behind her with my no. 5 knife, I was able to create an interesting in-and-out movement. Then I set up a different interaction between the mother and her supporting wall. There I used a brush to touch up the knifed-on textures and, after the impasto had set up, I thumbed the edges of the hat and back into the wall.

For this painting I used my no. 5 knife (see page 12).

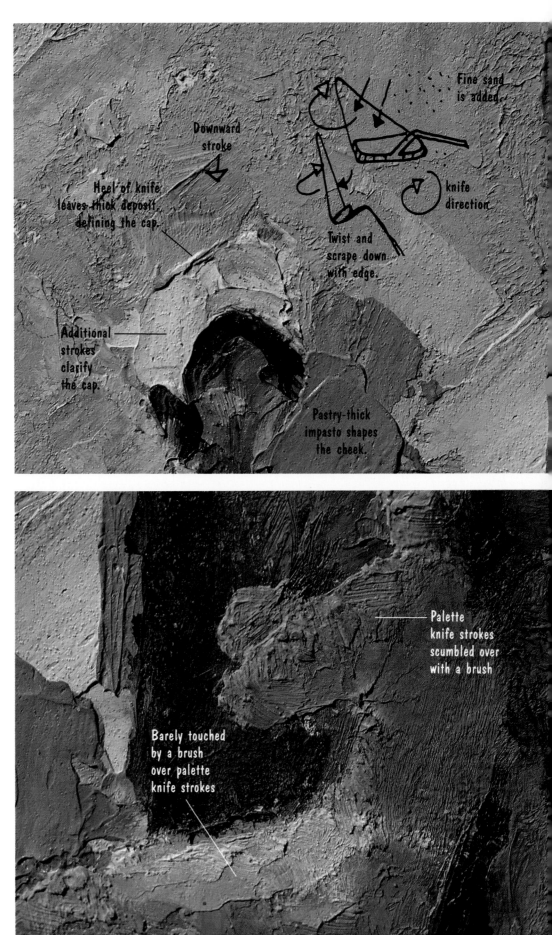

Downward stroke

Fine sand is added

Heel of knife leaves thick deposit defining the cap.

Twist and scrape down with edge.

knife direction

Additional strokes clarify the cap.

Pastry-thick impasto shapes the cheek.

Palette knife strokes scumbled over with a brush

Barely touched by a brush over palette knife strokes

Applying a Pudding-like Impasto

This group of snow-laden houses, with the distant mountains and overcast sky, seemed to demand a thick, rich impasto. To get the effect I wanted, I pre-mixed my colors in a pudding-like consistency and applied them enthusiastically, using a supple palette knife with a reinforced heel (no. 6 on page 12). The technique itself is a lot like icing a chocolate layer cake—you might even practice it by icing a cake.

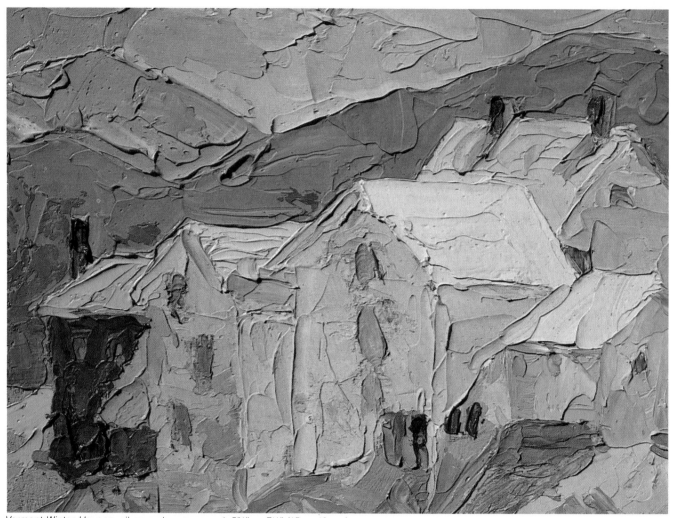

Vermont Winter Houses, oil on mahogany panel, 5⅞″ × 7½″ (15 × 19 cm)

To prevent any future cracking due to mishandling, I selected a rigid mahogany panel for my support. This panel had already—four months earlier—been primed with Grumbacher flake white in a slightly stippled texture and scrubbed with a pale ochre color.

After laying in my initial turps wash (using turpentine mixture no. 1), I let everything dry for 30 minutes while I whipped up a pile of Grumbacher flake white mixed with oil medium no.

5. I then pre-mixed 10 small mounds of color, much as I might do for a wood block or silk screen print. These mounds all have a chocolate-pudding consistency.

For a trowel, I used my 2⅜-inch (6-cm) palette knife (no. 6), which has a flexible front end but good control because of the reinforced heel. I worked quickly, letting the paint almost fly onto the panel. If you follow the numbers and letters in the diagram, you'll get an idea of how the painting

took shape. Then, about two hours after the light-colored houses, mountains, and sky were finished, I added the red chimneys and red house, providing a strong color balance for all the impasto texture.

This painting, with its thick impasto, was done more than 30 years ago. And it has not shown a single sign of cracking—one of the dangers with thick impasto. To play it safe, stick to the principle of fat over lean.

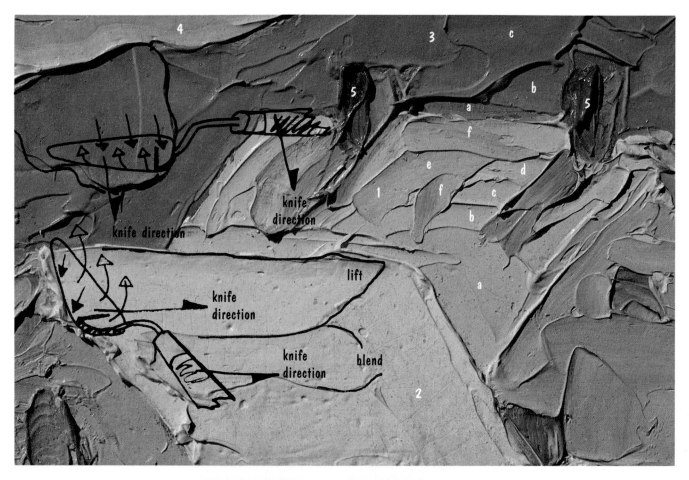

The numbers indicate the order of impasto application within the painting as a whole, while the letters specify the order within a particular section, such as the roof area. My knife was no. 6 on page 12, with a heavyweight heel.

The red chimneys and red house were added two hours after the rest was finished, as a color balance.

125

Accumulating Many Small Dabs of Paint

The jewel-like quality of the fields in this painting comes from the buildup of many small dabs of color, applied with my smallest painting knife. Although you might compare these many tiny gobs of color to the point-illist technique of Seurat, here the paint is much thicker and the strokes more varied. The broad, sweeping gestures of the distant mountains, as well as the clear horizontals and verticals of the barn, offer important points of contrast.

Mountain Silo and Barn, oil on Masonite, 6″ × 8″ (15 × 20 cm)

This painting offers an interesting contrast to the previous one (*Vermont Winter Houses*). In this case I mixed my colors directly on the palette, instead of pre-mixing them, and dabbed them on, *alla prima*, using my Ecolse 112 painting knife (no. 1 in the chart on page 12). I also used a slightly different oil medium—what I call oil medium no. 6, which has an ounce less turpentine than oil medium no. 5 (described on page 14). As a result, the impasto is a bit stiffer and glossier than in *Vermont Winter Houses*.

For my whites, I used equal amounts of Grumbacher flake white and Permalba white, thinned with oil medium no. 6, rather than turpentine mixture no. 2, to give more gloss to the finish. This mixture also gave the paint more "grab" on the small-peaked, stippled ground.

As you look at the details, notice how the many layers of paint on the buildings help to suggest weathered surfaces. Also observe how the many knife touches near the buildings augment the illusion of distance from the less detailed mountains.

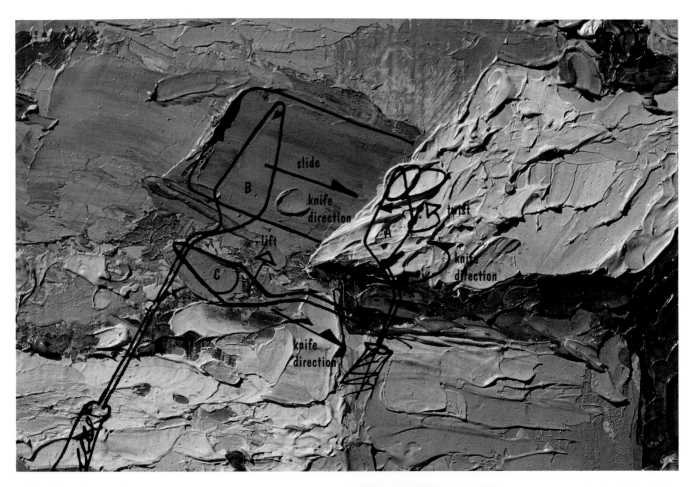

At point A, I twisted the knife to remove small, thick gobs of impasto with the tip. At point B, I slid on a full gob of buttery impasto. At point C, I pulled the knife backward, leaving two-thirds of a blade load.

Using my tiny no. 1 knife (see page 12), I built up many small touches of impasto, creating a jewel-like texture.

12.

REWORKING AND REDEVELOPING IDEAS

Painting should be a continual learning and exploring process. As I mentioned earlier, I like to let a painting gradually ripen in my studio. I'm not afraid to make major changes, and I'm not overanxious to finish it. I want it to be right. I also like to take the same subject or theme and explore it in different ways, working in a series. Take a look at Richard Diebenkorn's "Ocean Park" series, with its more than 100 variations. There is not one dull number, and you can see how his style has grown.

Moving to Thicker Impasto

My initial painting of this still life was done in a loose style with relatively thin layers of paint (see the discussion on pages 42–43). I liked the results, but I also felt an urge to try a different approach, using heavier impasto for a more classical interpretation. As you can see, I shifted my palette to a higher key, which seemed appropriate with the thicker, creamier paint.

At first I silhouetted this still life with a gray-white background and a yellow-white tablecloth. After letting these colors dry for two months, I reversed them. But some of the original gray shows through the new yellow background and some of the original yellow comes through the new white tablecloth . . . setting up quiet vibrations.

Notice that the kettles and fruit are also mottled in color, so they, too, vibrate. Also notice how the heavy impasto of the background has been carried into the kettle, particularly around the spout, to avoid a cut-out, pasted-on look.

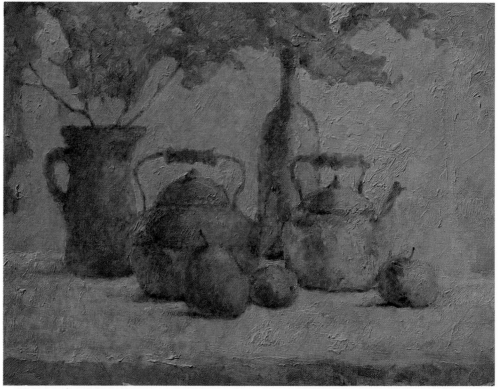

Kettles, Fruit, and Bougainvillea, oil on Masonite, 20" × 24" (51 × 61 cm)

The two tones of the tablecloth vibrate with light.

The mottled coloring of the pitcher and kettle contributes to the luminous quality of the whole.

The heavy impasto helps to accent the spout at the same time that it is carried into the kettle to avoid a cut-out look.

Studying and Correcting a Painting

My paintings often go through several "finished" stages before I arrive at a solution that just seems right. Once I've laid in all the elements and built them up with paint, the painting isn't necessarily done. Often I spend a lot of time fine-tuning the painting—making areas lighter or darker, clarifying or softening the edges, building up or removing some of the paint. This seascape, for example, could have been sold at an earlier stage, but I didn't feel enthusiastic about it. I kept it in my studio to study and eventually ended up correcting it. Always try to allow a little time to make sure you're satisfied (I allow at least a month) before you let a painting out of your studio.

To get the quality of a luminous gray day, I first laid in a light pink ground; then I brushed in this layer of raw umber, cobalt blue, and white (equal amounts of Winsor & Newton foundation white and Shiva underpainting white).

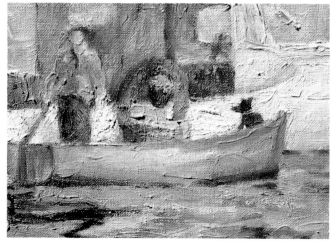

This detail shows a relatively early stage of the painting. I felt there was too much light all over and the shadows were too weak.

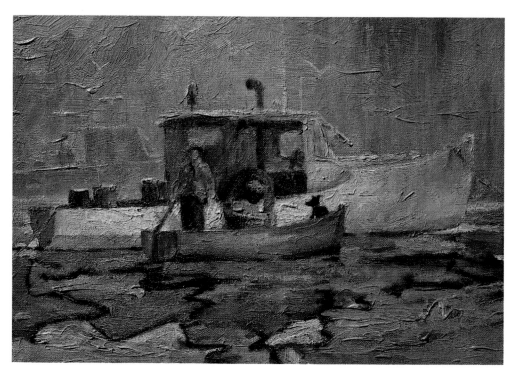

A few days later, I drybrushed the dark gray-blue rain streaks on the right; then I had to darken the lobstermen and their reflections.

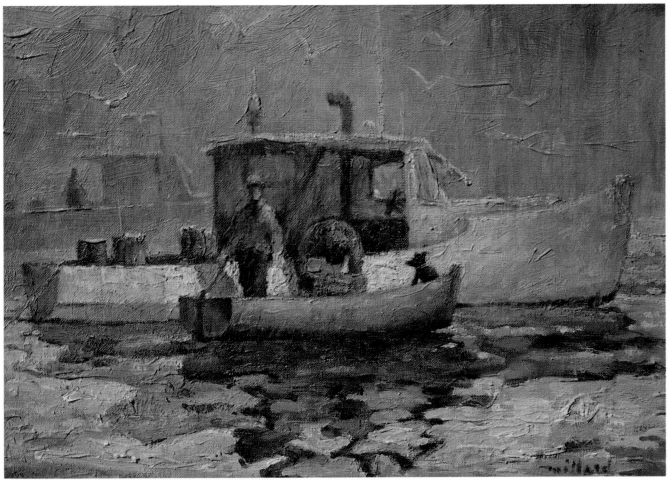

Lobstermen and Gulls, oil on linen, 12″ × 16″ (30 × 41 cm)

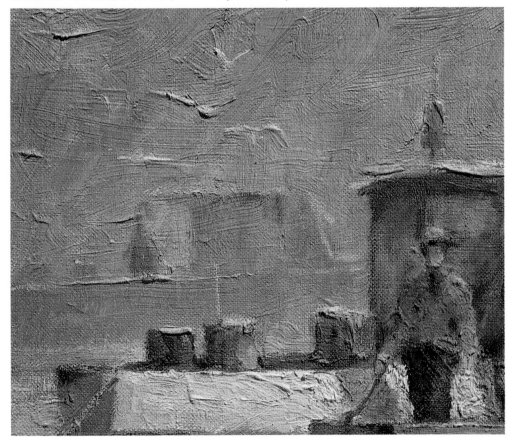

In the final stages, I tuned up the entire painting, correcting the values and simplifying the water. All the while, the paint was building up and getting crustier in texture—a definite improvement.

Notice how touches of heavier impasto define the gulls and, in a different way, clarify the central area, where the lobstermen are at work.

Brightening an Old Painting

If you're not happy with an old oil painting, feel free to rework it, giving it new life. Here I set out a new palette of brilliant Liquitex colors—acra crimson, bright aqua green, light and medium magenta, ultramarine violet, and turquoise green. These colors enticed me into creating a more exciting impasto roughness that would catch bright bits of light.

My first step was to clean the old painting with thinner to remove any grease or dirt, which would have interfered with the bonding of the new pigments. I did, however, keep the original vertical palette knife accents in the background, as I liked this impasto feature.

To begin the new painting, I drew in the dark purple outlines and then turned to the richly colored bits of texture. I deliberately kept the shadows dull, working with the less glossy oil medium no. 1, so they wouldn't catch or reflect light and thus spoil the illusion of depth. By adding oil medium no. 2 to my lights, I gave them a thicker, glossier look.

Notice the variety of brushmarks and palette knifestrokes throughout the painting and how they add excitement to the still life. Also notice how the impasto swirls move the eye around the painting. Now try to imagine this painting without the texture. Although the bright colors are important, they need the rough impasto for their impact.

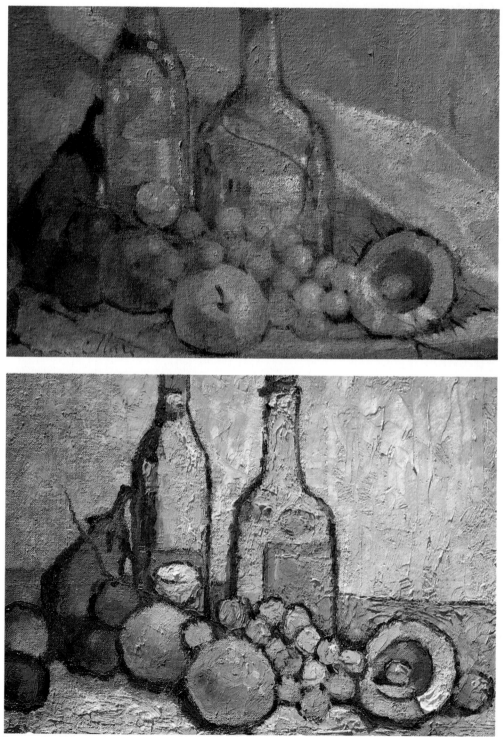

Grapes, Bottles, and Coconut, oil on linen, 9" × 12" (23 × 30 cm)

132

Tuning Up a Painting

This market scene is a good example of how I let a painting evolve. I began with a warm lay-in, using thin washes of color. Then, as I built up the touches of pigment, the painting took on a cooler cast. At a certain point I realized that although there were many lively touches of paint, the overall effect was duller than I wanted. The final step involved tuning up the colors to sing a brighter song. When you look from the start to the finish, there are a lot of changes . . . but the various steps felt right here and occurred as the painting grew and changed in my imagination.

This brown ink and oil sketch was done from memory on a piece of shellacked museum board. Although it's just a fragment, it was enough to get me launched on this small but complex oil painting.

Initially, I brushed in the market scene with Venetian red, cobalt blue, and cobalt violet. I then laid in a few contrasting color notes to define the fruit and vegetables.

The painting was built up with small dabs of paint, as were the windows of Vosges Bar *(page 73). The colors at this point were mostly cool blues and greens, with a few contrasting pinks.*

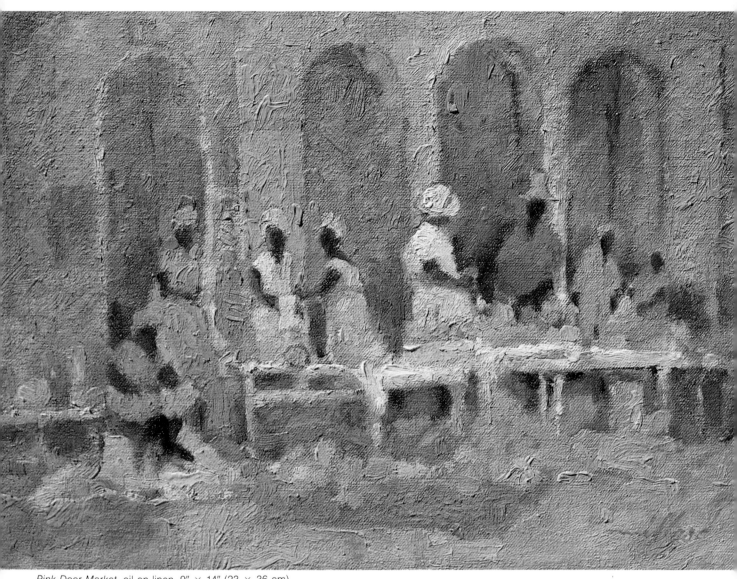

Pink Door Market, oil on linen, 9″ × 14″ (23 × 36 cm)

By intensifying the colors and adding some textured accents, I brought the whole scene into sharper focus. The brighter color and sharper definition also increased the feeling of light.

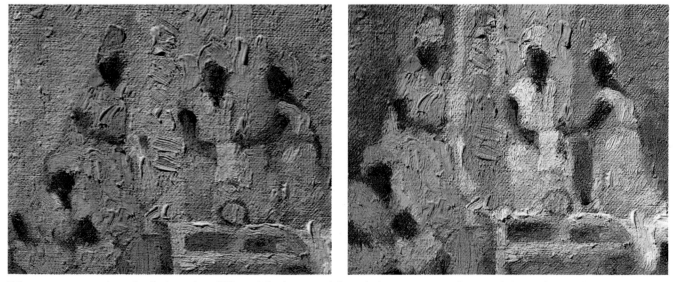

When you compare these details from the middle and final stages of the painting, you can see how much just a few touches of paint can do to change the feeling. Notice in particular how changes in the background color affect the figures in front.

Interpreting a Scene

Looking at the scene shown in the photograph, I thought the blank white wall covering the stairs would be a good setting for a group of figures. After doing a quick sketch, however, I decided that the balconies on the original building detracted from the figures, so I simplified and re-designed the architecture. Notice how the figures are carefully placed so the eye travels around from one to another. The varying thicknesses of impasto then act as counter-rhythms, also directing the eye.

To lay in the painting, I mixed my pigment with generous amounts of oil medium no. 1, thinning the paint with additional turpentine as necessary. By holding my Wharton long-bristle brush sideways and scrubbing vigorously, I allowed the light of the ground to show through in places, giving the impression of light reflected from the bright tropical surroundings. Then I let the painting dry for three days.

Gradually I built up the thickness of the paint, applying relatively flat textures on the building planes that faced the sun. For the staircase wall, however, I used a light color and heavy impasto at the top as an accent, with darker color and more moderate impasto around the figures. Also notice the intensity of the pink in the upper part of the building as it reflects the warm radiance of the sun.

To make the light in the painting "tangible," I made the girl's arm barely touch the wall, put a bit of light on the boy's shoulder, and let some light peep out from between his legs at the corner of the building. All this, remember, was invented. Painting light from my imagination frees me to create my own magic. Had I tried to record a photographic setup, I would have felt much more limited by the camera's impression. In this case the photograph served simply as a reference—the scene itself was for the most part created in my mind's eye.

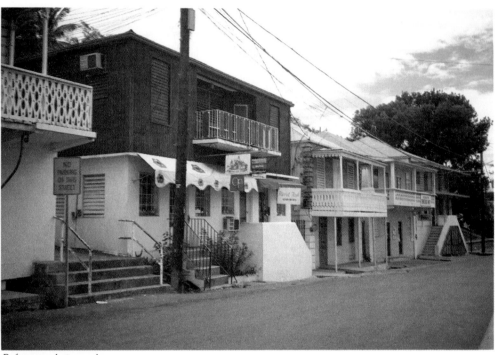

Reference photograph.

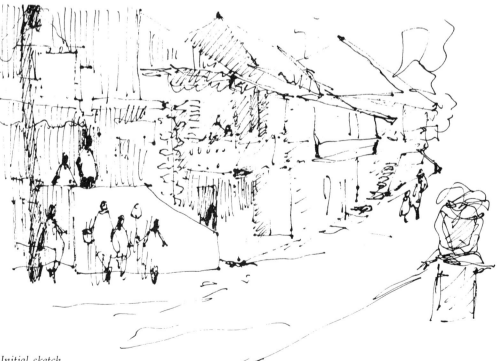

Initial sketch.

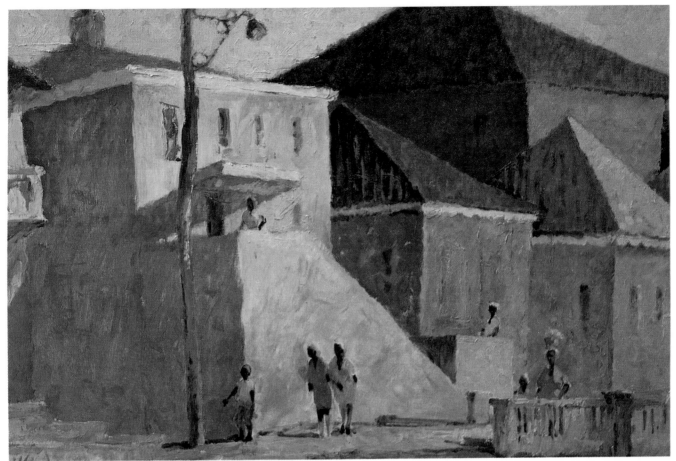

The African Store (first version), oil on Masonite, 24" × 48" (61 × 123 cm)

Later watercolor sketch (compare with page 140).

Reinterpreting the Same Scene

A second painting often comes to mind as you're painting the original concept. You may want to change the texture or use a different color treatment. In this case I tried a smaller version to see what would happen if I built opaque layers of pigment over complementary or analogous colors to create interesting visual vibrations. The only way to discover new impasto techniques is to experiment—and that's what I did here.

To clarify the light pattern, I use a mixture of ultramarine blue and madder deep.

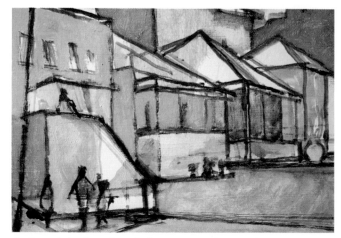

As I rough in the colors, I also correct and strengthen the architecture.

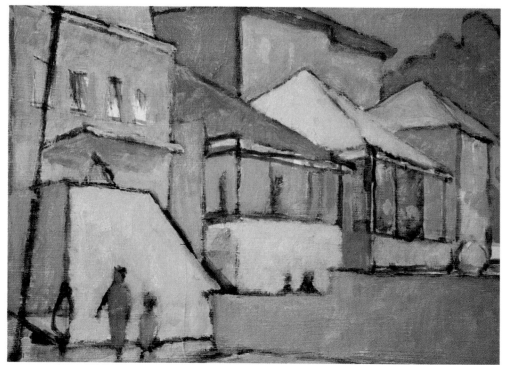

Here you can see the pink underpainting in the sky.

In the first version of this scene I used Grumbacher titanium and zinc whites but did not remove any oil, to allow for atmospheric scumbling. Here, however, I removed the oil by letting the titanium and zinc whites sit on brown paper for 15 minutes. Then I whipped them with some Winsor & Newton foundation white and turpentine mixture no. 1 to get a drier, more opaque impasto.

After sketching in the scene with a thin wash of cobalt blue and turpentine mixture no. 1, I decided to strengthen the light-dark contrasts with a mixture of Rembrandt ultramarine blue and Rembrandt madder deep. Next I roughed in the main colors. Turning to the sky, I laid in a layer of pink (made with Grumbacher cadmium red deep). Later, when it was sufficiently dry, I scumbled some Winsor & Newton viridian into it. I also placed a variety of greens in the trees and foliage, scumbled light touches of impasto over the darks of the buildings, and added details to the figures and fence.

Gradually I build up the colors in layers over my initial lay-in.

To keep these colors clean, I frequently scrape my palette.

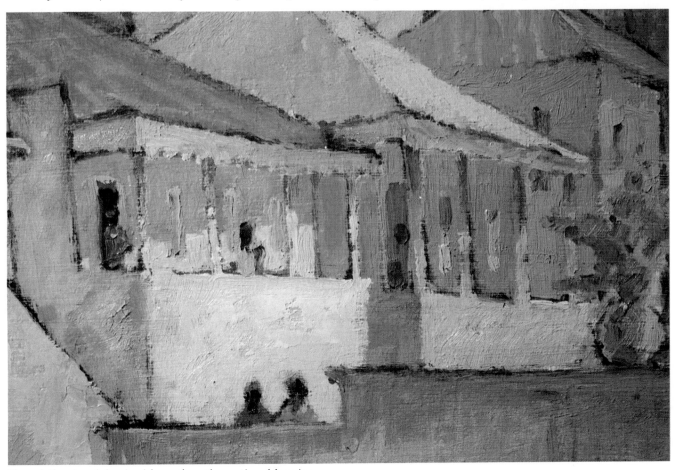

The painting is gaining in richness from the continued layering.

One of my aims in this painting was to create the illusion of sunlight by layering one color over another, getting progressively lighter in value. Look, for example, at the blue and orange houses; they gain their vibrancy from the buildup of impasto touches of color. It would be impossible to get this kind of color vibration from a single color application, in *alla prima* painting.

Overall, the painting has a luminous crustiness from the layering of both color and texture. The interplay of pink and green in the sky, the orange abutting the pink staircase wall, and the green trim on the orange house all add to the sparkle of the whole (see page 140).

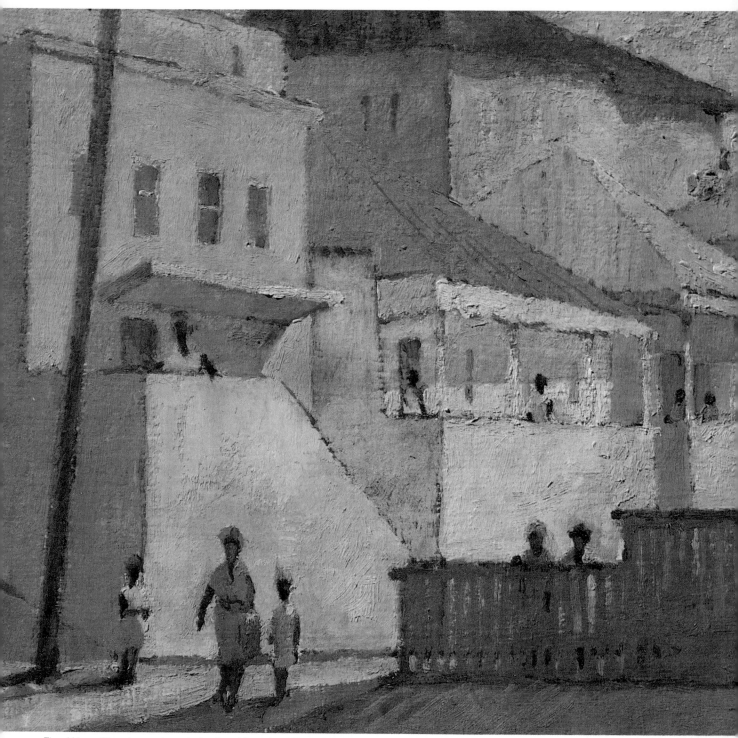

The African Store (second version), oil on Masonite, 10″ × 12″ (25 × 30 cm)

A luminous color vibration is set up by the interplay of the pink underpainting and the viridian on top.

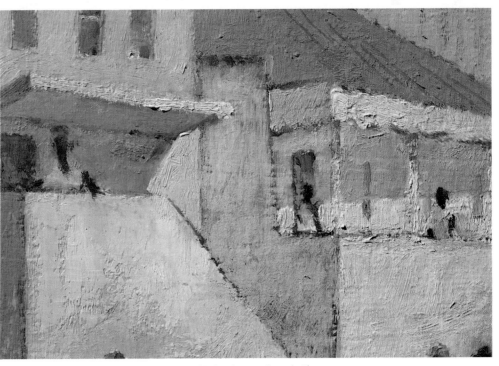

To get the texture you see here, I use the blade of my palette knife to flatten the paint, as shown in the demonstration on page 13.

MASTERS OF IMPASTO

Every artist learns from other artists. The following list includes a variety of artists who can teach you more about impasto. Each artist on this list paints differently, but all are highly creative thinkers, willing to take the time to daydream and unafraid of trying out new approaches. Looking at their work should encourage you to be inventive in your own painting and discover your own ideas about impasto.

Pierre Bonnard

I like the way he builds up varying thicknesses of paint to accent a bowl or some pieces of fruit. Often he creates a uniquely placed center of concentrated richness in a large field of rather simple texture.

Georges Braque

He uses earthy impasto in a design-oriented way, sometimes adding sand or other inorganic materials for texture.

Paul Cézanne

Study his paintings for their rich overall texture, sometimes built from many short diagonal strokes.

Jean-Baptiste-Siméon Chardin

His paintings have an exquisite surface, with a wonderful feeling of depth. In areas of his still lifes, you can see raised, dry, chalky textures. A museum docent once told me that Chardin added chalk to his flake white paint.

Edgar Degas

I mention Degas because he scraped down his impasto at the end of the day, leaving a thin remainder to build on.

Willem de Kooning

He can be demure or explosive in working his impasto magic. Not even a master ballet dancer could match the eloquent movement of his pigment.

Richard Diebenkorn

As he has moved from abstract to figurative to abstract work, there have been dramatic changes in his impasto techniques. The subtle beauty of his current overglazing technique is particularly remarkable.

Emile Gruppé

His paintings are filled with fluid, graceful impasto gestures. His "lesson of the day" was to use up a one-pound tube of zinc white on a 24 × 36-inch (61 × 91 cm) canvas.

Alfred Krakusin

As my painting professor at Colgate University, he gave me my first awareness of the textural possibilities of impasto.

Henri Matisse

It was after seeing some of Matisse's early (1901–1909) paintings that I started experimenting with impasto. What excited me was the way the original base colors kept breaking through subsequent layers of paint, creating exciting color vibrations and different visual depths.

Claude Monet

I'm particularly intrigued by the broken-edge effect of his brushwork in the haystack and Rouen Cathedral series. In studying one of his sunny cathedrals in detail (in the Clark Museum in Williamstown, Massachusetts), I realized that Monet built up a complex base of impasto before applying his final colors.

Giorgio Morandi

What is fascinating is the way he arrived at a subtle individuality for each motif while using nearly the same objects.

Julius Pascin

A sensuous figure painter, he develops complex gestures with limited amounts of pigment.

Camille Pissarro

This Impressionist was an inventive user of heavy impasto, working in smaller and shorter strokes than Cézanne (who painted with him for several years).

Robert Rauschenberg

Is there any other artist who could be so inventive and individualistic in moving from minute, textured rubbings of pigment to three-dimensional collage?

Rembrandt van Rijn

It is from him that I have learned how a small touch of thick impasto can rise above quiet surface textures to catch the light.

Pierre Auguste Renoir

His sensuous brushstrokes, creating soft or lost edges, produce a wonderful shimmer. Here the impasto is relatively thin, without lumps!

Larry Rivers

He may finish an oil with the initial turps wash, or he may go beyond a heavy impasto to add a wooden gun. I remember being particularly moved by his sensitive handling in heavy impasto of an elderly nude woman.

Georges Rouault

His rude, simple, jet-black outlines of heads and upper torsos are filled with layer upon layer of changing color, making for a be-jeweled, crusty surface.

Edward Seago

This contemporary English artist was a genius at preparing textured grounds for his oil paintings.

Chaim Soutine

With his brilliant, flamboyant brushwork, he pushes impasto into diverse textures, individualizing his subjects.

Vincent Van Gogh

He is probably the most consistent of these artists in using heavy impasto to model his form.

Edouard Vuillard

Using stiff, dry paint, he brings a sense of muffled quiet to his intimate scenes of interiors. He was particularly experimental in his use of dry pigment mixed in a glue base on cardboard for a matte, lusterless finish.

LIST OF WHITES

The individual personalities of my paintings have a lot to do with the different whites I use and the ways I combine them. The list below of basic whites is included to help you recognize how much the whites contribute to the character of the painting. To learn more, reread the section on handling whites (pages 17–19) and then experiment on your own.

page 24 (*Pumpkin and Pigeon Peas*), Grumbacher titanium and zinc; page 30 (*Marbi and Turnips*), Grumbacher flake white and Winsor & Newton foundation white (oil removed by leaving on paper 20 minutes), whipped with turpentine mixture no. 1; page 33 (*Pumpkin Seeds*), two parts Permalba white (with oil removed on brown paper for 10 minutes) whipped with one part Shiva underpainting white; page 35 (*Pansies and Hyacinths in a Blue Jar*), Shiva underpainting white and Grumbacher flake white (oil removed), whipped together; page 36 (*Lily and Seven Buds*), Shiva underpainting white; page 38 (*Violets in a Blue Jar*), Permalba white; page 39 (*Mums by the Window*), Grumbacher flake white; page 40 (*Lily Jungle*), Shiva underpainting and Permalba white; page 42 (*Kettles and Fruit*), Grumbacher titanium and zinc white; page 44 (*The Straw Hat*), Permalba white (oil removed) and oil medium no. 1; page 46 (*Silver Pitcher*), Permalba white (oil removed) and Shiva underpainting white; page 48 (*Savonierres, France*), Permalba white (oil removed on brown-paper bag for 5 minutes); page 49 (*Roya's Strawberries*), Grumbacher titanium and zinc white (no oil removed); page 50 (*Trawlermen*) Winsor & Newton flake white no. 1 (oil removed for 20 minutes) and Shiva underpainting white; page 53 (*Blue Book Arrangement*), Shiva underpainting and Winsor & Newton foundation white (squeezed out onto cardboard for 20 minutes to remove oil); page 54 (*Cheesecake*), Shiva underpainting white, Winsor & Newton flake

white no. 1, and turpentine mixture no. 1; page 56 (*Vineyard in Ventimiglia, Italy*), Permalba and Shiva underpainting white with oil medium no. 4 added in later stages; page 58 (*Burano Washerwoman*), Permalba and Shiva underpainting white, whipped; page 60 (*Avery's Birches, Vermont*), Grumbacher titanium and zinc white (oil removed on brown-paper bag for 15 minutes) with diluted oil medium no. 5 in my palette cup; page 63 (*Portrait of Preston*), Grumbacher titanium and zinc white (oil removed 5 minutes), whipped with turpentine mixture no. 1, with diluted oil medium no. 4 in my palette cup; page 65 (*Gloucester Weekenders*), Winsor & Newton foundation white (oil removed on brown-paper bag for 15 minutes); page 66 (*Beach Supper*), Grumbacher titanium and zinc white (a small amount); page 67 (*Last Leaves to Go*), Utrecht titanium and zinc white; page 68 (*Wood Bowl, Wine and Pomegranate*), Grumbacher flake white; page 70 (*Fishing the Cher River, France*), two parts Shiva underpainting white whipped with one part Winsor & Newton foundation white; page 73 (*Vosges Bar, Paris*), one part Winsor & Newton foundation white whipped with one part Liquitex titanium and zinc white (oil removed on paper plate for 5 minutes); page 74 (*Still Life on a Carpet*), Grumbacher titanium and zinc white with turpentine mixture no. 1 and oil medium no. 1 touched into all colors; page 76 (*Paper Bag Motif*), Grumbacher flake white (oil removed for 25 minutes, then whipped); page 79 (*Kennebunkport Elm*), Grumbacher flake white (oil removed); page 80 (*Nadine's Dark Grapes and Pear*), Permalba and Winsor & Newton foundation white (oil removed for 10 minutes), whipped; page 82 (*Morning Meeting*), Winsor & Newton foundation white (oil removed for 15 minutes); page 85 (*Wiscasset Stroll*), Grumbacher titanium and zinc white (oil removed for 5 minutes), whipped; page 86 (*Twin Farmhouses, Vermont*), two parts Grumbacher ti-

tanium and zinc white with one part Shiva underpainting white; page 89 (*Ligurian Mountain Cathedral, Italy*), Grumbacher flake white and turpentine mixture no. 1, with oil medium no. 4 for glaze base; page 91 (*Tea Tin and Pears*), equal parts of Winsor & Newton foundation white and Liquitex titanium and zinc white (oil removed for 15 minutes), whipped; page 92 (*Pineapple*), Winsor & Newton foundation white (oil removed on brown-paper bag for 15 minutes), whipped with turpentine mixture no. 2; page 94 (*Blue Balcony*), Winsor & Newton flake white no. 1 in soupy turpentine mixture no. 1; page 96 (*Synagogue Hill*), Winsor & Newton flake white no. 1 (with a bit of oil removed in early stages); page 99 (*Burano Burro*), one part Winsor & Newton foundation white (oil removed for 20 minutes) whipped with one-half part Shiva underpainting white; page 100 (*The Meeting Tree*), Grumbacher flake white (oil removed on paper plate for 20 minutes); page 102 (*Burano, Morning Chores*), equal parts of Grumbacher flake and Winsor & Newton foundation white (oil removed on brown-paper bag for 20 minutes), whipped; page 105 (*Dover Bridge*), Winsor & Newton foundation white and Grumbacher titanium and zinc white, mixed with diluted oil medium no. 4; page 106 (*Mr. Page*), Grumbacher flake white (oil removed for 10 minutes); page 108 (*Waterville Barns*), Permalba white (oil removed on brown-paper bag for 20 minutes); page 110 (*Ramo del Forno, Venice*), Grumbacher flake white, in all palette color mixtures; page 112 (*St. Tropez Tower*), Shiva underpainting white and Winsor & Newton foundation white (oil removed on brown-paper bag for 20 minutes), whipped; page 115 (*Gooseberry Chutney Jar*), Shiva underpainting white and Winsor & Newton foundation white (no oil removed), whipped, with a touch of oil medium no. 5 in last stages; page 116 (*Conch, Hibiscus, and Mangoes*), Permalba and Grumbacher titanium and zinc white

(whipped with turpentine mixture no. 2) and one-fourth part of Winsor & Newton flake white no. 2 (oil removed on brown-paper bag for 5 minutes); page 118 (*Carmel Mission*), Winsor & Newton foundation white (oil removed on brown-paper bag for 20 minutes); page 120 (*Pine Tree Laundry*); Grumbacher titanium and zinc white, whipped with turpentine mixture no. 1, then set aside for turpentine to evaporate for 15 minutes; page 122 (*Nurse, Mother, and Child*), Grumbacher flake white (oil removed), mixed with a few pinches of marble dust; page 124 (*Vermont Winter Houses*), Grumbacher flake white, whipped with oil medium no. 5; page 126 (*Mountain Silo and Barn*), equal parts of Grumbacher flake and Permalba white, thinned with oil medium no. 6; page 128 (*Kettles, Fruit, and Bougainvillea*), equal parts of Shiva underpainting and Winsor & Newton foundation white, whipped together then set to soak out oil for 5 minutes; page 131 (*Lobstermen and Gulls*), Winsor & Newton foundation and Shiva underpainting white (no oil removed); page 132 (*Grapes, Bottles, and Coconut*), Winsor & Newton foundation and Liquitex titanium and zinc white (oil removed on brown-paper bag for 15 minutes), whipped; page 134 (*Pink Door Market*, first version), one-half part Winsor & Newton foundation white whipped with one part Liquitex titanium and zinc white (oil removed for 15 minutes); page 135 (*Pink Door Market*, second version), one-fourth part Winsor & Newton foundation white whipped with one part Liquitex titanium and zinc white for drier mixture (oil removed for 15 minutes); page 137 (*African Store*, first version) Grumbacher titanium and zinc white (no oil removed); page 140 (*African Store*, second version), Grumbacher titanium and zinc white (oil removed on brown-paper bag for 15 minutes), whipped with two-thirds part Winsor & Newton foundation white, using turpentine mixture no. 1.

INDEX